Words and Images of

EDVARD MUNCH

BY BENTE TORJUSEN

CHELSEA GREEN PUBLISHING COMPANY, CHELSEA, VERMONT 05038

Library of Congress Cataloging-in-Publication Data

Torjusen, Bente, 1943-
 Words and Images of Edvard Munch

Bibliography: p.
1. Munch, Edvard, 1863–1944—Philosophy.
2. Munch, Edvard, 1863–1944—Psychology. I.Title.
N7053.M86A35 1986 760'.092'4 86-13685

ISBN 0-930031-05-9 (alk. paper)

For Anna and Matilda
my two daughters
who are a lively
and loving
part of the picture

ACKNOWLEDGEMENTS

This book was made possible in part through the generous per-mission of Alf Bøe to use material, words as well as images, from the vast collection of Munch-museet in Oslo. Among the museum staff I wish in particular to thank Ingebjørg Gunnarson, Sissel Biørnstad and Gerd Woll for their help and willingness to provide me with material, as well as Arne Eggum for many interesting discussions.

My warmest thanks to Tone Skedsmo of Nasjonalgalleriet, Oslo, for her prompt and generous help in supplying photographic ma-terial.

I wish to use this opportunity to express a special thanks to the former director of Oslo Kommunes Kunstsamlinger, Pål Hougen. Working with him on many exhibitions made me aware of how important Munch's written words are in relation to his art.

A number of people and institutions in the United States have contributed to this book in different ways. I wish to thank Nelson Blitz Jr. of New York City for permission to photograph and repro-duce works from his excellent collection of Munch prints. I am grateful to The J. Paul Getty Museum in Malibu, CA, for providing me with a transparency of the recently cleaned oil painting *Starry Night*. My warmest thanks go to Sarah G. and Lionel C. Epstein of Washington, DC, for their generous willingness to reproduce works from their superb Munch collection.

Prints from Edvard Munch's series The Mirror have a prominent place in this book. More than a decade ago I was fortunate to be involved in establishing the identity of the twelve surviving prints from this series. I wish to thank Kaare Berntsen Jr. of Oslo, who played a key role in this project.

The twelve prints from The Mirror series were exhibited for the first time since 1897 at the comprehensive Munch exhibition at the National Gallery of Art, Washington, DC, in 1978–1979. They are

reproduced in this book in color for the first time. A very special thanks goes to Philip Straus of New York City for his kindness, interest, and generous contribution in making the use of The Mirror series possible.

The following prints from The Mirror (page number in parenthesis) are reproduced courtesy of The Fogg Art Museum, Harvard University Art Museums, purchased through the generosity of Philip Straus, Class of 1937, and Lynn Straus: *Attraction I* (79), *Attraction II* (81), *The Kiss* (87), *Madonna* (90), *The Flower of Love* (100), *Vampire* (103), *Ashes* (107), *Separation II* (110), *The Mirror/Man's Head in Woman's Hair* (114), *Jealousy* (117), *The Urn* (123), and *Anxiety* (133).

Hathorn & Olson of Hanover, NH, and Jeff Nintzel of Plainfield, NH, have been most helpful in making their services available, as has Rick Stafford of the Photographic Services at The Fogg Art Museum. Many thanks also to Kathleen Palma of Norwich, VT, for invaluable, last-minute assistance.

I wish to thank Frank Lieberman for his kind, patient, and understanding help with the typography and design, and the publishers, Ian and Margo Baldwin, for their insight and flexible approach in expediting the complex development of this book. Thanks also to Leta Stathacos for her spontaneous idea for the book's jacket.

Last, but not the least, a special thanks to my husband, Clifford West, for his inspirational collaboration.

Bente Torjusen
Norwich, Vermont
May 1986

Abbreviations Used Throughout the Book

NBJR: Collection of Nelson Blitz Jr., New York, NY

EC: The Sarah G. and Lionel C. Epstein Collection, Washington, DC

JPGM: The J. Paul Getty Museum, Malibu, CA

HUAM: The Fogg Art Museum, Harvard University Art Museums, Cambridge, MA

NG: Nasjonalgalleriet, Oslo

OKK: Standard reference to any work or document in the collection of Munch-museet, which is part of Oslo Kommunes Kunstsamlinger (Oslo Municipal Art Collections)

PAS: Collection of Mr. and Mrs. Philip A. Straus, New York, NY

Sch: Standard reference to graphic works by Munch as registered in Gustav Schiefler, *Verzeichnis des Graphischen Werks Edvard Munchs bis 1906*, Berlin 1907, Oslo 1974

EMunch

BUT HOW ARE YOU THEN
MY NEGATIVE IMAGE -
THERE WHERE MY SOUL
FITS IN -

 E.M.

INTRODUCTION

A long time ago I had also intended to make a big portfolio of the most important prints in The Frieze of Life and to add my words to them—mainly poems in prose—

Edvard Munch, 1929

During his long, creative life the Norwegian artist Edvard Munch (1863–1944) made an impressive number of paintings and drawings, watercolors, and prints. He is perhaps best known today for the series of paintings and prints which he himself described as "a poem on life, love and death." Probing relentlessly into the depths of human emotions and the subconscious, Munch demonstrated in these works his exceptional ability to find adequate, visual expression for his own inner thoughts and feelings.

Munch was driven by a constant urge to experiment. It is therefore not surprising that many of his projects were left unfinished. It is, however, precisely within these unfinished projects that we find the essence of Munch's creative drive. One such project, a graphic series called The Mirror, plays a prominent role in this book.

Munch was a passionate and impatient searcher, who, while sensitive to outside influences, drew from his own art as his main source for new ideas. That is why there is both a pronounced cohesiveness in Munch's oeuvre, as well as an amazing variety in his artistic expression.

These same qualities apply to Munch's written work, as well. In addition to the several thousand works of art which Munch willed to the City of Oslo, he also bequeathed a vast amount of written material. Clearly Munch considered his writings to be of artistic value. In his will, written in 1940, Munch stated that the drafts for

15

his "literary works are to go to the City of Oslo, which in accord with the judgement of experts will decide whether and to what degree they are to be published." The year before his death, Munch told his friend Christian Gierløff about all the written material he had gathered over a period of sixty years, expressing concern as to how it should be organized. "I never use wastebaskets," he wrote, "therefore it is so terribly difficult to discern the wheat from the chaff."[1] Some years earlier, Munch had expressed a similar concern: "When I look through my notes, I find much of it naive . . . but since they are to be considered art—editing is needed and certain accidental complaints must be removed."[2]

Munch's written material is extremely various. Some of it is in the form of hastily written notes, in a barely discernible hand. In contrast, some of his prose poems he wrote in capitalized multi-colored letters and intended to have them accompany his important motifs.

Among Munch's writings was a vast correspondence; he often made several drafts of his letters. At times his handwriting is difficult to read. The violinist Eva Mudocci, with whom he was emotionally involved, exclaimed in a letter (1905): "Alas—you say that a man and a woman should not understand each other—so *that is* why you write so unclearly!"

In addition to his correspondence were numerous sketchbooks filled with notes and drawings. Many notebooks contained his so-called literary diaries—primarily descriptions of important events in his life. In some of these Munch recollected scenes of illness and death in his childhood home; in others he wrote about his first love affairs. Munch intended to gather these autobiographical writings into novels, but he never realized such plans.

Then there were heavy ledgers, in which Munch, over long periods of time, organized his writings on art and descriptions of the various moods and experiences he associated with his pictures. Inside one such book, labeled by Munch "Household Accounts," a satirical play entitled "The City of Free Love" was discovered. This "drama," as Munch referred to it, contained a biting attack on one of his former mistresses, Tulla Larsen. Munch wrote the drama in 1904 in response to his break up with Tulla two years earlier when he suffered a self-inflicted pistol wound in his left hand while they quarreled. The caricature drawings that accompany the play are marked by a grotesque sense of humor. The text is often rhymed to go with well-known hymns. In it Munch makes

parodic allusions to works by other writers, ranging from his friend, the poet Niels Collet Vogt, to Shakespeare.[3] One of the few written projects he ever finished, the play is meaningful only when seen in context with his life and work.

In 1909 Munch published a lithographic portfolio, *Alpha and Omega*. On a single sheet he wrote a text comprised of poetic, yet often ironical descriptions that related directly to the accompanying eighteen lithographs of the portfolio. Omega, the female protagonist, leaves Alpha to engage freely in sexual relations with a number of different animals on an Edenlike island. *Alpha and Omega* echoes the satirical quality of "The City of Free Love."

Munch gathered writings that dealt with his turbulent existence during the years 1902 to 1908 under the title "The Diary of the Mad Poet." He began this diary shortly before his hospitalization in Denmark following his nervous breakdown in the autumn of 1908. During this period Munch wrote Christian Gierløff of his intention "to write a kind of Don Quixote book about all my strange experiences."[4] He continued to be concerned with this subject matter for a long time; in fact, by 1929, it appears that he intended to include most of his earlier writing in "The Diary of the Mad Poet."

A large album called The Tree of Knowledge of Good and Evil shows how Munch attempted to integrate words and images. The album was probably never meant to be published but rather to serve as a personal source for his important motifs. Munch worked on this album over a period of many years, starting in the early 1900s. Prints and drawings he considered particularly important he inserted or glued into the book; some were drawn directly onto the pages. Many of the inserted works were executed in the 1890s. In this album Munch included texts that related to several of the pictures, although they were only rarely juxtaposed. Some of these texts, simplified versions of earlier writings, he described as "prose poems" or "poems in prose." Many of them are included in this present book. The dates of the texts are difficult to establish, although the loosely inserted pages tentatively have been dated 1912–1915. Some of the texts in colored crayon might have been written as late as the 1920s. In The Tree of Knowledge Munch also included texts which reflected his philosophy of life, a kind of religious pantheism. In addition, the album contains condensed versions of the childhood experiences Munch had written about earlier, as well as condensations of material from "The Diary of the Mad Poet."[5]

In 1929, during one of his periodic organizing spells, Munch explained to the Swedish art historian Ragnar Hoppe that he had been thinking of "gathering notes . . . what I call diaries of the soul, into a whole, and it takes time—I am now trying to organize this, but I do not know what it will lead to. I have had a few pamphlets printed."[6] Munch is referring here to two pamphlets in which he described his so-called Frieze of Life, a term he used for the first time in 1918. (The Frieze of Life refers to a number of related motifs—on love and anxiety, transformation and death—which Munch created in paintings and prints during the 1890s. He placed these motifs together for the first time in 1897 in the series of prints called The Mirror.) Of the two printed pamphlets, *Livsfrisen* (The Frieze of Life), must have been published in 1918. *Livsfrisens tilblivelse* (The Genesis of the Frieze of Life), also undated, appeared in 1929, in connection with a large retrospective exhibition in Oslo. Here Munch included some of his earlier texts, among them his well-known "Saint-Cloud Manifesto" (1889). In addition to *Livsfrisens tilblivelse*, he also wrote a few pages for the exhibition catalogue under the title "1889–1929: Small Excerpts from My Diary."

Munch thus tried to edit his writings in much the same way he edited or shifted the presentations of his paintings. During his frequent reorganizations of the pictures in The Frieze of Life, the principal themes of love, anxiety, and death remained constant, although the sequence of images presented for each of these themes varied. In addition, Munch habitually made new versions of his motifs, just as he habitually reformulated his texts.

Munch had an unusual ability to give both visual and written expression to powerful experiences and moods. Many of his written recollections of illness and death in his family preceded his visual formulations of these same experiences. The intense feeling of anxiety and inner turmoil which came upon him during a sunset one evening Munch first expressed in words. Later he came to grips with this particular experience pictorially in *Despair* and *The Scream*. Writing continued to be a vital part of Munch's artistic process. The drawing *Despair* (1892, page 134) is probably the earliest example that shows one of Munch's poetic texts in direct relationship to one of his images. During the 1890s Munch wrote several poetic texts adjacent to his pictures (*The Voice/Eyes*, page 72). In the letter quoted to Ragnar Hoppe, Munch stated: "A long time ago I also intended to make a big portfolio of the most impor-

tant prints in The Frieze of Life and to add my words to them—mainly poems in prose." The big portfolio mentioned by Munch could hardly have been anything else but the graphic series The Mirror. The themes of The Mirror are death and transmutation, love, and anxiety—in other words, the main themes of what Munch came to call The Frieze of Life. The Mirror series was shown at a large retrospective exhibition in Oslo (then Kristiania) September–October 1897. In the catalogue Munch listed the prints which belonged to The Mirror and announced his intention to publish, "in the near future," a number of portfolios of this series. This plan was never realized, although Munch seems to have continued working on it for a few more years.

The development of The Mirror series, and the circumstances under which it was created, are particularly important to gain a fuller understanding of Munch as an artist and as a writer. As exhibited in 1897, The Mirror series must have consisted of at least twenty-five prints (see page 45 for a complete listing of the prints belonging to The Mirror). The Mirror was never exhibited again during Munch's lifetime. He is said to have given prints from this series to a mistress in France.[7] Thirty years after Munch's death, twelve prints—nine lithographs and three woodcuts—were identified as belonging to the original Mirror series. Now in the collection of the Harvard University Art Museums, the twelve extant Mirror prints are still mounted the way Munch presented them in 1897. He trimmed the edges of these prints closely and at times rather unevenly, as can be seen in their reproductions in this book. He then pasted the images onto brown cardboard. Six of these prints are hand-colored; we can tell that this was done after Munch mounted them, since paint has spilled over the edges onto the cardboard in a few cases. The most startling image is perhaps the title picture, a unique hand-colored version of the woodcut Man's Head in Woman's Hair (page 114), which in the 1897 catalogue was listed under the title The Mirror. Along the upper edge of this image, Munch painted in black watercolored capital letters "SPEILET ANDEN DEL 1897" (The Mirror Second Part 1897).

Except for the title picture, Munch wrote his name in pencil on the cardboard underneath the righthand corner of each print and dated them all 1897. Even prints made in 1895 and 1896 were here dated 1897. This dating highlights the fact that Munch must have considered the serial presentation of The Mirror prints important. By giving the prints such a similar and distinct mounting, he also

emphasized their interdependence. We do not know whether Munch presented his works in a way that unambiguously stated their interrelationships before 1897, but we are certain he did it after The Mirror series exhibit. In 1903 in Leipzig he showed a number of his Frieze of Life paintings against a neutral, unifying band of background material—a fact well documented by photographs.

The cardboards onto which Munch mounted The Mirror prints are considerably larger than the prints themselves. It is thus possible Munch might have planned to publish a portfolio of The Mirror with texts written on the cardboard, beneath the prints. In 1895 he had a short text printed in German underneath his lithograph of *The Scream* (page 139). By 1897 Munch had written a number of poetic texts that are related thematically to the images in The Mirror series. We know that Munch was particularly involved with writing poetry after The Mirror exhibition. In a March 1898 letter Munch told his friend, the German poet Max Dauthendey, that he had been busy "writing poetry—that is to say, concentrated thoughts and experiences." It is not unlikely that Munch was in the throes of attempting to edit and organize his writings to accompany The Mirror portfolio.

Throughout his life Munch was particularly close to literature and to writers. He developed an early interest in literature in his childhood home, where his father, a medical doctor from an old, distinguished family, often read to the children from sources as diverse as the Bible, the sagas of Norway, Dostoevski, and Dickens. The writings of Edvard's famous uncle, the historian P. A. Munch, were also favored reading.

In the early 1880s Munch began his career as a painter, and he soon became associated with a group of radical artists and writers known as The Kristiania Bohême. In 1885 the leader of this group, the writer and anarchist Hans Jæger, published his novel *Fra Kristiania-Bohêmen* (From the Kristiania Bohême). Because of its supposed immoral contents, the book was confiscated and the author sentenced to imprisonment. Hans Jæger believed in total freedom from social and religious morality and recommended free love instead of marriage. For Munch, who grew up in a strictly religious home, some of Jæger's theories were difficult to accept. Nevertheless, Jæger's uncompromising, if somewhat monotonous, de-

scriptions of his love affairs contributed to the development of Munch's own writing and creative ideas, ideas he was to explore in depth in the 1890s when he worked on a series of paintings and prints under the title Love.

One of the commandments of the Bohemian group was: "Thou shall write thine own life." In this spirit Munch began writing in the late 1880s about his illicit love affair with a married woman, whom he referred to as "Mrs. Heiberg." Despite his involvement with literary self-examination, Munch grew bored with the trend among young Norwegian intellectuals to write at length about their lives. "Now I begin to feel a little fed up with all these people who write their lives," Munch said in a letter to the Danish poet Emanuel Goldstein in 1891. He continued: ". . .one moves around in constant fear of being dragged up to the seventh floor and there be presented with a life in 2000 pages—here in Norway there is hardly a man who has not written a novel about his life."

In his "Saint-Cloud Manifesto" Munch declared that he would "no longer paint interiors of people reading and women knitting." Instead, he wanted to paint "living beings, who breathe and feel, suffer and love." Such an emphasis on man's inner nature was, in fact, strongly echoed in Norwegian as well as other European literature around 1890. Younger Norwegian poets found a number of their ideas visually confirmed in Munch's art. In 1892 Vilhelm Krag, who had written poems directly inspired by Munch's paintings, asked Munch to illustrate a collection of his poems. Munch made several sketches, but they were never published. Similarly, Munch agreed to make illustrations for poems by Sigbjørn Obstfelder. Though this project was never brought to fruition either, the exchange of such ideas must have had an impact on Munch as a writer.

While Munch was in France in 1889–1890, a close friendship developed between him and the poet Emanuel Goldstein. Their mutual interest in and understanding of art and literature led to plans (never realized) to publish a magazine. In late 1891 Goldstein asked Munch to make a frontispiece for a second edition of his book Alruner, which he dedicated to Edvard Munch. Munch then made a number of sketches inspired by Goldstein's poems. The one he chose to finish for the frontispiece is a dramatic and somber pen-and-ink variation of the Melancholy theme.

When Munch arrived in Berlin in the autumn of 1892 he again became active in a predominantly literary milieu. He had come to

Berlin to exhibit at the unexpected invitation of the Verein Berliner Künstler (The Berlin Artist Association). Just as unexpectedly, Munch achieved notariety overnight as a result of the sudden closing of his exhibition. Some of the more conservative members of the Association found Munch's paintings too provocative.

Munch did not seem to regret the publicity, and he spent much of the next three years in Germany establishing a name for himself. He had become increasingly aware of a need to present his pictures in a meaningful context—as a series. He believed his pictures with related moods would be better understood when they were exhibited together. In 1893 his series of paintings entitled Love began to take form.

During his stay in Berlin Munch had an intense social and intellectual life. This was the time of the so-called Ferkel group. The name referred to a favorite gathering place in Berlin, a small tavern which August Strindberg had named "Zum Schwarzen Ferkel" (At the Black Piglet). The Swedish dramatist was the most prominent among the many artists and writers who gathered there. The Norwegian writer Gunnar Heiberg, the Danish poet Holger Drachmann, the Polish writer Stanislaw Przybyszewski, who was also one of the first to write a biography of Munch, and the German poet Richard Dehmel, to mention but a few, were all regulars at the Schwarze Ferkel. After Strindberg's death in 1912, Munch wrote a vivid poetic description of Strindberg and the Ferkel group:

> Strindberg is gone—A friend is gone—
> Two rows of pictures emerge—from the daily
> company in Berlin the winter 1892–93
> At the end table in Schwarze Ferkel
> surrounded by Germans Danes Swedes Finns
> Norwegians and Russians—glowingly serenaded
> by the young German poets—
> In particular Dehmel who stood on the table
> with bottles falling around him—paying homage
> And first performances of his plays—
> The sentences fell like swordblows. . .
> now like swords, now like daggers
> —soon it seethed like the table wine—
> glowing red glowing white dripping sweating
> —burning all around him—
> now emerging bringing us in his hands

Inferno—and *Legends*—
Probably the most remarkable novels
since Raskolnikov

It began with *The Red Room* for us
Norwegians—the world that is named
Strindberg—the one who along with some
other writers contributed to make unrest—[8]

Munch and Strindberg spent a great deal of time together in
1892–1893. Strindberg was then particularly absorbed in his own
original, expressive form of landscape painting; the friendship
with Munch seemed to have rekindled his desire to paint. In June
1893 paintings by both Strindberg and Munch were included in a
salon de réfusé in Berlin, attracting considerable attention.

Many of the earlier members of the Kristiania Bohême had
joined the Ferkel group by 1893. Early that year Munch introduced
a beautiful Norwegian music student, Dagny Juell, to his circle of
friends. Their reactions were immediate. She became the fascinat-
ing center of their attention and generated immediate emotional
tension. Both Strindberg and Munch were attracted to her. In the
autumn of 1893 she married Stanislaw Przybyszewski.

The charged emotional and literary atmosphere that character-
ized the nightly gatherings at the Schwarze Ferkel must have stim-
ulated both the writer and the artist in Munch. A newspaper article
described the ambience among the Ferkel members and reported
Munch was a regular nightly visitor. The article also reported that
Munch, after having received two Norwegian government schol-
arships to pursue his career as an artist, had given up painting and
"translated his ideas into words and wasted them on the
'Schwarze Ferkel' public."[9] The fact Munch not only wrote but
also read his own words to his artist and writer friends indicates
that he must have felt quite at ease expressing himself this way.

A new magazine for art and literature, *Pan*, was founded in
Berlin in 1894, and many of the Ferkel members were contributors.
One of *Pan*'s editors, the young German art historian Julius Meier-
Graefe, became one of Munch's greatest supporters. Meier-
Graefe was clearly aware of Munch's unique potential as a print-
maker, a career he had just embarked on.

Munch started as a printmaker with etchings and engravings at
the end of 1893. By 1895 he had also mastered the technique of
lithography. Many of his prints were of motifs he had previously

23

painted. Munch wanted his art to be seen by as many people as possible. "Art is man's need to communicate," he once wrote. He also felt a need to keep his works grouped around the themes that preoccupied him. Printmaking thus afforded him a broader audience and at the same time enabled him to keep his works together.

In June 1895 Meier-Graefe published a portfolio of eight of Munch's etchings and an explanatory introduction by Meier-Graefe himself. The eight etchings were not related through subject matter, but Meier-Graefe mentioned in his introduction that Munch was almost finished with the etchings and lithographs of his Love cycle. Thus as early as 1895 Munch had already developed the idea of a graphic portfolio of related motifs. During 1896 and 1897 there are many references pointing to the fact that Munch was working on a graphic portfolio called Love. Never finished, it was later incorporated into Munch's graphic series The Mirror. In the same manner, his series of paintings called Love eventually became part of The Frieze of Life.

In printmaking Munch found an ideal method for bringing into focus the interrelationships of his work. He undoubtedly saw printmaking as a means of publishing his own words alongside his own images. During his residence in Berlin Munch may have been thinking of publishing his Love prints, accompanied by his own words, in German. There are two German texts by Munch, one with a translator's corrections, on the back of one of his lithographs of *The Scream*.

While he was in France during 1896–1897 Munch continued to develop his idea for a portfolio of important motifs combined with his own words. In the 1895 December edition of the avant-garde art magazine *La Revue Blanche*, Munch's lithograph of *The Scream* was reproduced. A text by Munch was printed in French beneath the image. The editor, Thadee Natanson, who had met Munch in Oslo the year before, explained that "the text. . .is one of those little poems which Mr. Munch has the habit of adding to his compositions." In 1896 Munch was also introduced as an artist and writer when he was published for the first time in an American art magazine. The January edition of *M'lle New York* featured a lithograph of *The Scream*. Vance Thompson, the editor, noted the fact that the artist had interpreted the motif in his own words.

The Paris milieu Munch now came into contact with was characterized by a great variety of artistic activity: art, literature, theater,

and music. Munch continued to enjoy the company of former friends, mainly from the literary world, such as Krag, Obstfelder, Knut Hamsun, and Strindberg. He now established new friendships with both artists and writers in Paris. He became acquainted with Stéphane Mallarmé, the foremost French symbolist poet of the time, and made two portraits of him, a lithograph and an etching. Equally important were his friendships with minor poets, today virtually forgotten. The poet and psychiatrist, Marcel Réja, greatly admired by Strindberg, is but one example. Réja wrote a poem with the inscription "For an Album on Love—The Plant," dedicated to Munch. This poem was obviously meant to go with Munch's 1896 lithograph *The Flower of Love*, a motif that was to be included in The Mirror (see page 100).

To explore more fully the possibilities of printmaking, Munch could not have chosen a better place than Paris. Auguste Clot, the renowned printer who did most of Toulouse-Lautrec's colored lithographs, was also to print for Munch. *The Sick Child* (1896), one of Munch's most exquisite colored lithographs, was printed by Clot in a number of color variations (see page 64 for one example).

It was during this time that Munch started working with woodcuts, a technique which eminently suited the kind of primitive sophistication that often characterizes his work. The woodcuts of Felix Vallotton and of Paul Gauguin were important to Munch in his search for his own expression in that technique. He immediately became aware of the particular quality that could be obtained by utilizing the textures in the grain of wood as expressive elements (see *Melancholy*, page 120, as an outstanding example).

Munch began experimenting with color prints as well, in lithographs, woodcuts, and mezzotint. Fascinated with this new possibility, he tried out subtle color variations within one and the same motif. He printed many of his graphic works of this period on brightly colored paper. Sometimes he added color by hand, as he did with some of The Mirror prints. To print in color Munch often utilized a uniquely simple and direct approach. Instead of preparing one block for each color, he sawed a block into different pieces, colored each piece separately, put each back together like the pieces of a puzzle, and obtained the desired color effect by printing the woodblock only once (for examples, see *Encounter in Space*, page 98, and *The Girl and the Heart*, page 115). In other instances, he used several blocks, one for the drawing and one or

more for the colors (*Melancholy*, page 120).

Munch was stimulated in his creative work with woodcuts through his association with William Molard and his family at their Montparnasse home. William Molard, whose father was French and mother Norwegian, earned his income as an employee in the French Ministry of Agriculture. In his free time he composed music that was considered rather avant-garde. Although none of his compositions have survived, it has been suggested he influenced composers like Florent Schmidt and Maurice Ravel.[10] He was married to a Swedish sculptress, Ida Ericson, and their home became an important gathering place for French and Scandinavian painters, writers, and musicians. By 1895 Strindberg had become a regular visitor at the Molard's, who often lent him a helping hand with his translations. In his autobiographical novel *Inferno* Strindberg returned this favor by describing the Molard family and their weekly gatherings in rather sarcastic terms. Among the regular visitors at their soirées were painters like Vuillard, Bonnard, Marquet, and Daniel de Monfreid. The composer Frederic Delius often visited, as did the young playwright Alfred Jarry and the poet Julien Leclercq. The Molard home was also a meeting place for the young intellectuals connected with the periodical *Mercure de France*.

Ida and William Molard were close friends of Paul Gauguin, who had moved into a studio on the floor above them during the winter of 1893–1894. Gauguin was then experimenting with woodcuts intended as illustrations for his planned publication of *Noa Noa*—a manuscript that contained Gauguin's written impressions of his first stay in Tahiti. In fact, Gauguin made some of these woodcuts in a corner of the Molard's apartment, since he had run out of studio space. In June 1895, when Gauguin traveled to Tahiti for the second and last time, he left a number of woodcuts that were trial proofs for *Noa Noa* with the Molards. Gauguin also asked William Molard to represent his interests in connection with any publication of *Noa Noa*.

Munch often discussed his own graphic works with Molard, and he must have welcomed the opportunity to study the Gauguin woodcuts in the Molard home. He must also have been aware of some of the different plans for *Noa Noa*. At one point, for instance, Gauguin had worked on the manuscript with the poet Charles Morice. This version of *Noa Noa* was published by Morice in *La Revue Blanche* in 1897. In learning about Gauguin's *Noa Noa*

projects, Munch's ambition to publish his own prints and words together was quite possibly reinforced.

Munch might also have learned more about Gauguin from Strindberg. At the weekly Molard gatherings Strindberg often played the guitar, and Gauguin, the mandolin. Strindberg had written a subsequently well-known letter to Gauguin that was used as a foreword in the catalogue for the auction of Gauguin's paintings at the Hôtel Drouot in February 1895. When Munch arrived in Paris in late February 1896, he renewed his friendship with Strindberg, and during the spring and early summer of that year they spent a lot of time together. Strindberg was now in his so-called Inferno period and was increasingly preoccupied with alchemy, occultism, and chemical experiments. By the middle of July 1896, when Strindberg's crisis seemed to have reached a climax, he and Munch were no longer on close terms. He now regarded Munch as being on the side of "the enemy." Munch wrote to his aunt in August, "Strindberg has gone home to Sweden—he is supposed to be treated for his insanity—he had so many strange ideas—made gold, and found out that the earth was flat and that the stars were holes in the dome of heaven."

However, before their break a vivid exchange of ideas took place between Munch and Strindberg. In May 1896 Munch opened an exhibition at Samuel Bing's Salon de l'Art Nouveau. Strindberg, who also had a name as an art critic, wrote a review of this exhibition, published in the June edition of *La Revue Blanche*. This review caused more of a stir than did Munch's exhibition. Strindberg described eight works by Munch, among others, *Kiss*, *Jealousy*, *Vampire*, *Madonna*, and *The Scream*. For each of them, he gave a short interpretive description, which actually revealed more about Strindberg and his pessimistic, misogynistic views, than they did about Munch's works. Later, in a letter to Ragnar Hoppe, Munch was to refer to these characterizations as "poems in prose." In the same letter Munch described some of his own writings as "poems in prose."[11]

In the summer of 1896 Munch must have come in possession of Strindberg's original manuscript for *Le Plaidoyer d'un fou* (*A Madman's Manifesto*), which had been published the year before in Paris. The novel, in which Strindberg lays bare the story of his first marriage, was written in French in 1887–1888. Strindberg himself had characterized this novel "as revealing as the Kristiania Bohême. . ." The fact that Munch possessed this Strindberg manu-

script probably influenced him to resume his own autobiographical writing, which he did in 1898, after his relationship with Tulla Larsen had begun. It has been suggested that Munch deliberately used his affair with Tulla to gather material for a roman á clef in the spirit of *Le Plaidoyer d'un fou*.[12] Strindberg's novel reveals the kind of bitterness and one-sided negative view of women similar to that expressed in Munch's autobiographical writings before his nervous breakdown in 1908. During their time together in Paris Strindberg was writing *Inferno*, which was published the following year. In 1896 Strindberg was even considering the idea of publishing *Inferno* as an illustrated manuscript. In the summer of 1897, a friend of Strindberg, who had met Munch in Oslo, told the Swedish writer that Munch had given up painting to write a novel called *Hell*.[13]

In April 1896 Munch was commissioned by La Société des Cents Bibliophiles to make illustrations for Charles Baudelaire's *Les Fleurs du mal*. The project was cancelled in June because of the publisher's sudden death. Munch, however, had become deeply involved in this work, and made several sketches for illustrations for some of the poems. In the Baudelaire project, he developed a concept of illustrating a page where the text became an integrated part of the whole. A similar idea is conveyed in the drawing *Separation/Melancholy*, executed around this time, where Munch left space for a text in the middle of the drawing (see page 113).

The death of the publisher, Monsieur Piat, seems to have moved Munch deeply. He wrote about it in his sketchbooks and alluded to it in his drawings. Piat was an old man, and Munch undoubtedly found in him a father figure. For several years after his own father's death in November 1889 Munch wrote extensively about death and what happens after death. He wrote about transformation, asserting that the human substance does not disappear but becomes transformed (page 66). The poems of Baudelaire Munch had chosen to illustrate, "Une Charogne" and "Le Mort Joyeux," expressed thoughts that coincided with his own preoccupation with love, death, and what happens after death. Munch wrote an interpretation of "Une Charogne" in a small sketchbook of the late 1890s. The poem's notion—that, even when a loved one dies, the essence of this beloved lives on in the work of art created from the artist's memory—was undoubtedly significant for Munch.

In Baudelaire's poetry, with its constantly recurring themes of love and death and its fundamental emphasis on the cohesion

between man and the universe, between the material and the spiritual, Munch found much that corresponded closely with his own outlook. The occult, mystical, and at times demonic quality of Baudelaire's poetry must have been a source of discussion between Munch and Strindberg. The Mirror print *The Urn*, as well as the text Munch wrote for it (pages 122–123), suggests Baudelaire's and Strindberg's influences. Moreover, the theme of *The Urn*, rebirth, became fundamentally important for the genesis of The Mirror series.

The word *mirror* suggests reversal. If we consider the events of Munch's early years, we may understand why he needed to initiate The Mirror series with the themes of illness, death, and transformation woven in at the outset. Munch's mother died when he was five years old; his beloved sister Sophie died from tuberculosis at the age of fifteen, when he was fourteen. Suffering frequently from poor health, Munch was, a year before his sister's death, so ill that he was not expected to survive. Late in life, Munch described his home as "the home of illness and death," adding, "Indeed I have never overcome these disasters. They have also been decisive for my art." [14] Thus, his tragic childhood and youth, his frequent encounters with death, became an important factor in the development of his art. Death was to give life to his art.

In March 1898 William Molard wrote Munch from Paris, wondering if he was still working on his lithographic album "in which you wanted to mirror all the different phases of your life's—soul's life." Unlike Narcissus, Munch was compelled constantly to gaze beyond the surface into the depths of his soul, where he found images from his past, images which remained, for him, "inner visions of the soul . . . on the other side of the eye."[15] These were images of illness, death, suffering, love, and anxiety. Narcissus was transformed into a flower; Munch used a blossom to symbolize the art which grew from his own life (see *Blossom of Pain*, and accompanying text pages 48–49).

There is an almost religious intensity in Munch's search for an answer to the meaning of life. From his childhood on he was thoroughly familiar with the Bible, but his views of religion came to differ radically from the fanatical views of his father. Even if he did not want to believe in the frequent childhood threats of eternal punishment, these threats instilled in him a deep fear of life. In

his art he often used religious symbols, but only as a point of departure and in a manner which broke with traditional renderings of biblical motifs (see for example the Madonna images on pages 89, 90, and 92). The title "The Tree of Knowledge of Good and Evil" has obvious biblical connotations. In fact, the Bible could easily have inspired Munch to use The Mirror as the title for his first series of thematic works. In the first letter to the Corinthians, Chapter 13, the chapter on the virtues of love, the image of a mirror is used to describe partial understanding: "For now we see in a mirror, dimly, but then face to face; now I know in part, but then I shall know fully. . . ."

In the same chapter of Corinthians is written: ". . . if I have all faith, so as to remove mountains, and do not have love, I am nothing." While he was in Paris in the late summer of 1896, Munch wrote a note that began with an allegorical description bearing remarkable parallels to the Biblical verse:

> I have never loved—I have felt the kind of passion which moves mountains and transforms people— love which tears layers from my heart and drinks blood—but to no one have I been able to say— Woman it is you whom I love—You are my all—

> But how are you then my negative image—there where my soul fits in—[16]

Love is for Munch often synonymous with suffering. Also, Munch had a tendency to see himself, in a quasi-religious way, as someone who suffered on behalf of others. He frequently described suffering and pain in terms of a bleeding heart. In numerous pictures, for example in *Separation* (page 109), suffering is symbolized by a man holding his hand to his bleeding heart. From the blood which drips to the ground, a flower rises up.

The title picture of The Mirror—a unique version of the woodcut *Man's Head in Woman's Hair* (page 114)—is an example of how Munch, in a more indirect and abstract way, expressed the concept of suffering caused by love. This particular motif of a man's head encircled by a woman's hair, contains elements from many other love motifs, such as the one's in *Vampire* (page 103), *Attraction* (pages 79 and 81), *Separation* (pages 109,110 and 113), *Jealousy* (page 117), and *Melancholy* (page 120), as well as elements from the motif in *The Girl And The Heart* (page 115). Seen in this context, the title The Mirror becomes meaningful not only for the

series as a whole, but also for the title picture itself, since it reflects thematic elements from many other images.

The title picture is treated quite differently than the traditional woodcut of *Man's Head in Woman's Hair*. From a print of this motif, Munch cut out the shapes of the heads and glued them onto a large piece of brown cardboard. He then painted this cardboard with vibrant brushstrokes of red watercolor, ranging from deep scarlet on the woman's throat, to a light crimson around the man's head. In a few places in the woman's hair he used gold paint, which harmonizes with his written descriptions, such as "your hair has golden dust" (see page 72).

The red color in the title picture of The Mirror evokes a mood of both passion and pain and takes on the same significance as the red heart in the woodcut of *The Girl and the Heart*. Created in 1899, Munch almost certainly intended to include this image in a portfolio that has a print of *Man's Head in Woman's Hair* on the cover. He pasted a print of *The Girl and the Heart* onto large brown cardboard, similar to the way he treated the original Mirror prints.[17]

A small pencil drawing of the *Separation/Melancholy* theme (page 113) and the text juxtaposed with it (page 112), help to clarify the relation between *Man's Head in Woman's Hair* and *The Girl and the Heart*. In the "Separation" part of this drawing, Munch has left space for a text. We do not know whether it was for a text of his own, or for another writer's work. It is, however, worth noting that the mood of Munch's text juxtaposed with this drawing is curiously similar to the mood of Max Dauthendey's book *Die Schwarze Sonne* (The Black Sun). Munch had taken particular interest in this book, and he expressed this in a draft of a letter to Dauthendey in 1898: "Many of the moods [in *Die Schwarze Sonne*] are remarkably similar to my dreams—and death pictures—and I understand it very well."

The lower level of the drawing, depicting the Separation motif, is closely related to the way Munch expressed this motif in lithographs and paintings. The upper level with the Melancholy motif contains several interesting features. The melancholy young man, sitting broodingly on the beach, cannot escape thoughts of the woman who left him. He is therefore "framed in" by her. On the right side is a woman's head, bent down, her hair covering her face, while in her outstretched hands she holds a heart. Above the man is depicted what at first glance seems like a landscape of

gently curved hills. Closer observation reveals the bottom half of a woman's body (lying face down). The woman is the landscape that frames and preoccupies the man.

The text, which harmonizes with the mood in this drawing, ends in the following agonizing way: ". . . then I still felt how it hurt there where my heart was bleeding—because the threads could not be torn."

This drawing indicates how the motifs of *Man's Head in Woman's Hair* and *The Girl and the Heart* belong together. Both motifs depict the face of a young girl in profile. The red color in the background of The Mirror print becomes the red heart in *The Girl and the Heart*. At the same time the shape of the heart is reminiscent of the form of the man's head in the title picture. Both images depict the young girl's face in profile, and both show her eye from frontal view. When thus seen in close juxtaposition the parallels between these two pictures are startling. Both clearly show how Munch drew inspiration from his own work to create new images of striking simplicity.

In a broader sense Munch, in his exploration of the various graphic techniques, drew from a similar pattern of inspiration within his own work. In the late 1890s he was increasingly involved in experimenting with color woodcuts. This may have interrupted his plan to publish The Mirror series. Some of these woodcuts, such as *The Girl and the Heart* and *Encounter in Space*, both done in 1899, Munch probably intended to include in a revised version of The Mirror series. However, Munch never put together a revised series, nor did he ever realize his idea of making a portfolio of colored woodcuts.

Munch seemed particularly sensitive to how one art form could enrich another. He spoke of his own pictures as "poems," and as having the effect of "a symphony." A number of Munch's friends characterized his art as both poetic and musical. His friend Dauthendey, along with the Swedish writer Gustaf Uddgren, were ardent spokesmen for an art form which aimed at achieving a fusion that appealed to all the senses. They regarded Munch, with his affinity for both music and literature, as the foremost spokesman for this direction in art.[18] Members of the various literary groups Munch frequented during the 1890s took a great interest in music as well as art. While in Paris in 1896 Munch often spent time with the composer Frederick Delius, who was an art connoisseur. In

1899 Munch wrote to Delius, referring to an idea they previously must have discussed: "Why don't we work out our plans for that idea with engravings and music—and J. P. Jacobsen?" Both men had long been interested in the work of the Danish writer Jens Peter Jacobsen, and Delius had set music to several of Jacobsen's poems. Unfortunately we have little further evidence that sheds more light on this proposed collaboration; we do not know if it was intended as a publication with poetry, images, and musical scores, or if it was to be presented as a live performance, with Munch's pictures as a backdrop.[19]

In the process of working on a theme again and again in his art, Munch often deleted what he regarded as unnecessary detail. By removing these extraneous elements, he more easily translated his personal experiences into the universal language of art. This same paring-down approach is evident in his writings that relate to his most important images. In the course of this process of simplification a measure of Munch's lyrical, tender qualities, as well as the intensity of his anxiety, sometimes becomes lost. However, the motif or theme usually gains in emblematic expression and poignant strength. Several of The Frieze of Life motifs show a parallel development in words and pictures, from the more narrational, detailed, and personal toward greater simplification and concentration. By juxtaposing Munch's words and image, we gain an amplification of the essential moods he strove to create.

An autobiographical feeling is established in the pencil drawing *Adieu/The Kiss* (ca. 1890) where the setting is the artist's studio. The accompanying text is taken from one of Munch's autobiographical notes (for both image and text see pages 82 and 83). Fairly detailed, it evokes a tender, sensitive mood with an undertone of sadness. Juxtaposed with the etching of *The Kiss* is a more simplified text (pages 84 and 85), where the emphasis is on the loving couple, as in the etching. A Tree of Knowledge text accompanies the hand-colored woodcut of *The Kiss* (pages 86–87)—a Mirror motif (1897). (Munch was to print even more simplified woodcuts of this motif; he included one such version of *The Kiss* (1902) in The Tree of Knowledge.) Short, poignant, and simplified, Munch extracted the essence from his earlier writings; the burning lips, the dark eyes, the sensation of being transported into another world. Munch wrote the words in multicolored crayon to emphasize the ideas in the text.

Munch's earlier autobiographical writings show Hans Jæger's

influence. Not only did he follow the commandment of "write thine own life," but he also used the same unorthodox spelling as Jæger. Both writers obtained surprising effects by spelling words as they were pronounced.

Munch's written recollections of illness and death in his childhood home evoke strong visual images. His writing here conveys intense feeling and emotion. The process of writing almost certainly helped him understand how he was to deal with these themes pictorially.

At times Munch gives the impression of writing in a stream-of-consciousness manner. To a great extent this is due to his unusual lack of punctuation. Only rarely did he use periods; occasionally, a comma, an exclamation, or question mark. His unique method of writing was characterized by a frequent use of dashes, or "thought lines" as they are called in Norwegian. Often Munch initiated a sentence without any indication of the ending of the previous sentence, at times leaving only small spaces between them. Thus a peculiar rhythmic flow characterizes many of his texts. In some passages the dashes are used very frequently, creating a staccato rhythm, like a series of short brushstrokes, giving an impressionistic effect. In other instances, the sentences are interrupted less often by dashes, creating a feeling similar to that of longer, flowing brushstrokes. In some of the shorter, simplified prose poems, there is no punctuation at all; the texts stand out as one intense, concentrated whole (for example, see the text to *Ashes*, page 106).

In his autobiographical accounts Munch often wrote about himself in the first as well as third person. When he assumed the role of a young man in love, he often disguised himself under the names Nansen or Brandt. (In his play "The City of Free Love," Munch is "The Singer," his former mistress Tulla Larsen, the daughter of a rich merchant, is "The Dollar Princess," the writer Gunnar Heiberg, who at that time had fallen in deepest disgrace with Munch, is "The Swine," and so forth.) Munch's habit of referring to himself in both the first and third person is evident in his haunting descriptions of his almost fatal illness at the age of thirteen. He recalled this illness in an agonized account some fourteen years later (pages 55–58). In this text Munch's father is referred to as "Daddy" and "the Doctor." Munch is the "I," the protagonist of the dramatic action, and at the same time he is "Karl" or "he" who is able to watch the entire drama unfold. Far

34

from being a neutral observer, he is intensely involved, with a striking ability to analyze his own participation—and that of his family—in the action.

In the 1894 pencil drawing *Fever* (page 54), we face the bedridden boy, who is overcome with feverish hallucinations. In the related pastel (1893) and lithograph (1896), *By the Deathbed* (pages 55 and 59), we barely see the dying one, but we experience part of the scene with his eyes. We see the hallucinated faces as Munch saw them, and at the same time we see the family members gathered in grief around the bed. Here is an element of both "I" and "he": "I," the dying one, "he," the passionate observer analyzing the grieving reactions of the family members.

This particular ability of Munch's to analyze the action without losing a sense of intense involvement in the drama undoubtedly contributed to his strong affinity with the theater. In 1894 Munch became acquainted with the well-known French actor and director of the Theatre de l'Oeuvre, Aurelien Lugné-Poë. Two years later Lugné-Poë commissioned Munch to create the cover for a theater program for Henrik Ibsen's *Peer Gynt*. Munch was an ardent admirer of Ibsen, whose plays inspired many of his works. In 1906 Munch was invited to make sketches for stage sets for performances of Ibsen's plays in Max Reinhardt's Kammerspiele Theater in Berlin. He became particularly involved with the sketches for *Ghosts*, in which he incorporated elements from several of his death-room pictures.

In *Death in the Sickroom* (page 60) Munch demonstrates his capacity to create an intense psychological drama through his placement of the figures—the dramatis personae—within a clearly defined room or stage. The paralyzing tension of grief comes through forcefully. The feeling of isolation, apparent in both the groups and the individuals, results from Munch's simple use of various frontal and profile positions.

Ibsen reciprocated Munch's admiration. He must have appreciated the inner dramatic quality of much of Munch's work. In his pamphlet *Livsfrisens tilblivelse* Munch recalled how Ibsen, when visiting his 1895 exhibition in Oslo, expressed a great interest in the pictures. Questioned by Ibsen, Munch explained The Frieze of Life motifs, in particular, his painting *Woman in Three Stages*. Munch wrote that Ibsen drew inspiration from this picture for his last play, *When We Dead Awaken*, written in 1898.

In the letter William Molard wrote to Munch in 1898 he men-

tioned that he had just finished writing music to a play by Paul Roinard, called *Les Miroirs* (!), explaining that he had looked upon it "as an exercise in composing simply, on the theory that the music is to function as scenery, a sort of backdrop, before which the characteristic emotions of the play are to be portrayed." There is an intriguing correspondence between Molard's concept of how his music was to function for the play *Les Miroirs*, and how Munch presented his Mirror series of prints.

In Munch's paintings and prints on the theme of love the undulating shoreline with the ocean and the forest on each side provides a mood-creating stage set. The monumental oil painting *Starry Night* (1893, page 77), sets the tone for the sequence of the Attraction motifs (pages 79 and 81). The somber glow of the bluish nuances in the painting evokes a mood of mysterious premonition. This painting clearly reveals Munch's ability to capture the mood of a landscape as he had experienced it in a moment of emotional intensity. The text chosen to accompany this painting is more concretely detailed than the image. Yet the writing reinforces the emotional quality Munch sought to express in the painting. The text describes how Munch and "Mrs. Heiberg" are looking out a window into the soft summer night. As in *The Scream*, the actual place where the event occurred can easily be identified. However, this setting has relevance only as point of departure for a fuller understanding of the expressive qualities in his art. Munch said it in the following way:

> The thing is that one sees differently at different times. One sees in a different way in the morning than in the evening. The way in which one sees also depends upon the mood one is in. It is this that causes one to see a motif in many ways, and it is this that gives art an interest. . . .
>
> . . . one wants to express something that one has experienced in an erotic moment when one is warm with passionate love One has in such a moment discovered a motif Then one cannot express this exactly as one sees it another time when one is cold. One experiences everything quite differently when one is warm than when one is cold.
>
> And it is just this and only this which brings a deeper meaning to art It is the human being, life which one must express. Not dead nature.[20]

In *Starry Night* the feeling of premonition is enhanced by the shadow—that of a couple—on the white fence, giving a subtle hint of what is to come. In *Attraction I*, we find the same stage set as in *Starry Night*: the contour of the massive tree, the undulating shoreline, the stars in the sky, the white fence that gives depth to the image. Here Munch's use of blue watercolor in the night sky captures the mysterious, dreamlike quality of a Norwegian summer night. The shadow in the painting has been replaced by the young couple facing each other. The short poetic text that accompanies *Attraction I* echoes the mood of this image.

Looking more closely at Munch's prose poems, we see he repeatedly used certain expressions. In the texts juxtaposed with the various images of *The Voice*, *Attraction*, and *The Kiss*, one such leitmotif is the expression "two big dark eyes," which Munch often compares with "two dark heavens." When *Attraction I* was exhibited as part of The Mirror series in 1897, it was entitled *Stars*, a title that referred to the two small stars in the sky. Munch saw the two stars as a cosmic counterpart to the two dark eyes. Nature represented more than a mood-creating stage set for Munch. The sky and the ocean, in particular, symbolized human beings' connection to forces beyond their comprehension and control. In 1896, when Munch printed *Attraction I*, he wrote, "One gets accustomed to everything—even to the star—the same star—always every evening—. . . ."[21] Seen in such a context the Attraction motif is logically continued in *Encounter in Space*.

In one of the several texts Munch wrote for *Encounter in Space*, he compared his vision of love between man and woman to that of a pair of stars which come close to each other, barely touch one another, only to vanish in different directions (see page 96). This motif appears in the lithograph *Decorative Design* (1897, pages 96–97). In it, the man and the woman reach out to each other in an arch. In *Attraction I*, Munch shaped the upper edge of the print into an arch to emphasize the concept of the dome of heaven. Thus, a connection between the Attraction motif and the theme of *Encounter in Space* suggests itself, a connection that becomes more evident by the juxtaposition of the words Munch wrote for these images.

In *Decorative Design* the man and the woman are connected by ribbons tied around their feet, a detail that creates a certain ambivalent feeling. Munch often symbolized the emotional ties between man and woman, whether positive or negative, through

undulating lines. He frequently used the woman's long, flowing hair to show these ties. He established a similar feeling in his prose poems through his recurrent use of words like "fine threads" or "lines" that tie the man and the woman together. In a 1896 letter to the Danish poet Helge Rode, Munch inquired if Rode, in a recently published book, had taken the expression "threads are tied between our eyes" from his own imagination, or if he had heard Munch use it: ". . .have I read to you from some of my papers—because I have almost word for word what you have (it was written to an etching)."[22]

In Munch's Separation motifs (pages 109, 110 and 113) the woman is leaving the man, yet her hair is still connected to his heart, causing pain. Later in life, with a more removed perspective, he described his use of undulating, connective lines in the following manner:

> I sought simplification—something I by the way always have done—It was the iron construction (as it now is the concrete) the Eiffel Tower—it was the tense arch which later was relaxed in the Art Nouveau style—Actually the wavelines also had their root in the discovery and indication of new forces in space—Radiowaves and one sensed the communication from one person to another—
>
> (Separation: I symbolized the connection between the separated ones through the long undulating hair . . . the long hair is a kind of telephone line.)[23]

Many of the texts that Munch inserted or wrote in The Tree of Knowledge indicate that the visual impact of the written word was important to him. Several of the prose poems in this album are rendered in watercolor or multicolored crayon. At times text and drawing overlap each other, as in *A Mysterious Stare* (page 116). One of the texts for *Madonna* as it appears in The Tree of Knowledge was written in red watercolor. The red color accords with the feeling of passion and pain, which is so essential to both the image and the text for *Madonna*. The prose poem in The Tree of Knowledge, though written at a fairly late date, reflects the spirit of Munch's texts written for this motif in the 1890s (see for instance page 91). Above the watercolor and gouache motif of *Lovers in Waves* Munch wrote an accompanying text in pencil and watercolor. The colors of the image are in various red and violet hues in

harmony with the last line of the text (see pages 94–95).

The similarity of the texts chosen for *Lovers in Waves* and *Madonna* makes clear how these motifs are related to each other. The halolike wavelines around the madonna's head find their counterpart in the waves surrounding the lovers in *Lovers in Waves* (see pages 92–93). The ocean, like the sky in *Attraction I*, becomes a symbol of the mysterious and transcendent dimension of the meeting between man and woman. Or, as Munch expresses it in the text to *Lovers in Waves*: "Now the chain is bound which ties generations to generations—Like one body we glide out upon a vast ocean. . . ."

To Munch, anxiety, like suffering, seemed an inevitable consequence of love. Therefore, when he exhibited his work under the title "Love" during the 1890s, he also included pictures that dealt with anxiety. A motif like the one in *Evening on Karl Johan* helps clarify how the love motifs relate to the theme of anxiety. In several early autobiographical notes, Munch wrote about experiences that he subsequently expressed visually in the painting *Evening on Karl Johan* (1892) and in a hand-colored lithograph, known to exist only in one version (1896, page 130).

In one such autobiographical text (page 131) Munch wrote in detail of his walking up and down Karl Johan—Oslo's main thoroughfare—waiting for "Mrs. Heiberg" to appear. His description of the light, right after sunset, and its effect on the cityscape and the people, is rendered in clear, visual terms. Love-filled anticipation forms the initial part of the description. "Mrs. Heiberg" then appears in the crowd, only to disappear again. Their inability to communicate is expressed by Munch in terms of loneliness and isolation: ". . . everything became so empty and he felt so alone . . . People who passed by looked so strange and awkward and he felt as if they looked at him stared at him all these faces pale in the evening light—." The contrast between the crowd of people and the lonely individual is important in both the text and the image. The unsettling feeling created in this image is subtly amplified by the border of death masks at the bottom of the print.

In the various texts and versions of *The Scream*, Munch also expressed isolation by emphasizing the distance between himself and his two friends who continued to walk on without him, unaffected by his inner turmoil. In *Evening on Karl Johan* there is as well a feeling of isolation among the people within the crowd, which Munch emphasized by giving them masklike, expression-

less faces. In *Anxiety*—a hand-colored woodcut which was included in The Mirror (page 133)—the idea of isolation within a crowd is central. Here Munch tells us explicitly that he sees beneath the surface, "I saw all people behind their masks. . . ."

One prominent feature in Munch's art, apparent in both his images and his words, is the element of repetition. As he did with many of his pictorial motifs, Munch would play with variations of the same theme in words. The text where this variation occurs most frequently is the one that relates to *The Scream*. In one of his earliest descriptions, written next to his drawing *Despair*, Munch describes his overwhelming reaction to a sunset (pages 134–135). Another text, very similar to that of *Despair*, has an additional dramatic description of the clouds "dripping, steaming blood" (page 136). Much later Munch wrote a text for *The Scream* in The Tree of Knowledge (page 138). The extreme simplification of this text shows how the passage of time changed the intensity of the initial experience.

In The Mirror series of prints Munch combined themes of death and love for the first time, in 1897. In this series, which he initiated with the death motifs, he was trying to explain "life and its meaning." Only after he clarified his own life could he go on and "help others clarify theirs." This was precisely what he meant to do in The Frieze of Life, when five years later, in 1902 at the Berliner Secession he presented his paintings as a series that included all the principal themes of The Mirror in the first full exhibition of The Frieze of Life paintings. However, the sequence in which the main themes were presented differed. By ending The Frieze of Life paintings with the death motifs, Munch presented his work in a less idiosyncratic and private order.

The images reproduced in this book are of Munch's drawings, paintings, and prints. There is, however, a predominance of prints, partly because Munch's words harmonize best with his printed images, partly because Munch himself so often stated that he intended to publish a portfolio of his prints with his own words. The motifs are presented in a sequence which is basically true to that adopted in The Mirror exhibition of 1897: thus, the death and transformation themes are followed by the love and anxiety motifs. The twelve extant prints from the original Mirror series are reproduced in full color for the first time in this book. They are readily identifiable by their brown backgrounds.

Self-portraits precede the death motifs. The texts accompanying these portraits describe and clarify the circumstances and experiences that were determining factors for Munch's art. Autobiographical notes of an intensely dramatic nature as well as texts with a more reflective quality accompany the images of death and transformation. The love motifs follow. The majority of Munch's prose poems were created to go with his love images. A number were written for specific image themes (*Attraction, The Kiss, Madonna, Separation*). Other texts, such as the ones juxtaposed with *Mystery on the Shore* (page 68), *Young Girl on the Shore* (pages 70–71), or *The Girl and the Heart* (page 115), were chosen because they reflect moods or ideas similar to the ones expressed in these images.

The texts are taken from a variety of Munch's writings done over a period of decades. The sources for each text are listed in the back of the book. Many of the texts are familiar to Munch scholars. However, the unobtrusive juxtaposition of Munch's own words with his images allows the artist to speak directly to his public. Some of the texts have been hand-lettered by Clifford West, who is himself an artist thoroughly familiar with Munch's work. The hand-lettering gives that sense of variety so characteristic of Munch and attempts to capture—not to copy—the spirit of Munch's texts as they appear in The Tree of Knowledge. Other texts are lettered by hand to convey a more personal, intimate feeling. Occasional words are accentuated with an interpretative color, just as Munch in some instances did.

In the few cases where I have used an already existing translation, this is indicated in the notes to Munch's texts in the back of the book. Like others who have attempted to translate his words, I was faced with the problem of punctuation. As previously discussed, much of the expressive quality in Munch's writing is due to the rhythmic flow of words, accentuated by his frequent use of dashes. In pursuit of authenticity, I have preserved Munch's style of punctuation.

This book deals with only a fragment of the artist's written oeuvre. Munch's writings, descriptive and enigmatic, powerful and poetic, become especially meaningful when seen in direct relation to his art.

B. T.

NOTES

1 Edvard Munch in a letter to Christian Gierløff, 1943; see Christian Gierløff, *Edvard Munch selv*, Oslo, 1953, p. 295.

2 From OKK T 2734, in an introduction Munch wrote in 1929 to "The Diary of the Mad Poet" of 1908.

3 "The City of Free Love" is published in Norwegian in the catalogue *Edvard Munch: Alfa & Omega*, Munch-museet, March–May 1981, pp. 61–76. Munch alludes to Shakespeare's *Macbeth*, when referring to the episode with his injured finger, op. cit., p. 67. Munch writes of three witches ("the unburnt witches' pack"), and his second witch paraphrases Shakespeare's first witch in *Macbeth*, Act 1, Scene III: "Here I have a pilot's thumb, / Wreck'd as homeward he did come."

4 Letter written at Dr. Jacobson's Clinic, dated Copenhagen, Kochs vej, November 27, 1908, see Gierløff, op. cit., p. 289. In a previous letter to Gierløff, dated May 13, 1908 (OKK T 2745), Munch wrote: ". . . I am eagerly at work writing the story from beginning to end. . . . I believe that those who know me realize that I can also draw in words the animalistic instincts of my fellow human beings in a painterly characteristic and powerful way. . . . Now I must start working on the book, which I believe soon will be finished—it will initially be printed only in a few copies."

5 See Gerd Woll, "The Tree of Knowledge of Good and Evil," in *Edvard Munch: Symbols & Images*, catalogue, National Gallery of Art, Washington, DC, November 1978–February 1979, pp. 229–247 for a detailed account of this album.

6 Edvard Munch in a letter to Dr. Ragnar Hoppe, February 1929, in Ragnar Hoppe, "Hos Edvard Munch på Ekely," *Nutida Konst* I, Stockholm, 1939, pp. 16–17.

7 Mentioned by a late Norwegian collector who acquired twelve prints—later identified as Mirror prints—in Berlin in the early 1930s: in a 1973 conversation with Kaare Berntsen Sr. and Jr. of Oslo. For a detailed discussion of The Mirror series, see Bente Torjusen, "The Mirror," in *Symbols & Images*, pp. 185–227.

8 Munch initiated this undated note, without registration number, as a letter to an unidentified German "Frau." As often is the case when Munch wrote drafts for letters, he dropped the original subject and continued with thoughts that preoccupied him at the time (cf. note 16). Most likely, Munch had just learned about the death of Strindberg when he wrote this recollection. The line "Strindberg is gone—a friend is gone" has been incorrectly deciphered from Munch's barely discernible handwriting as "Strindberg looked away—We look away" (e.g., Carla Lathe in *Edvard Munch and his Literary Associates*, catalogue, University of East Anglia, Norwich, England, June–October 1979, p. 28).

9 According to Reinhold Heller, this anonymous article is by a "Ferkel" member, the writer Franz Servaes. See Heller, "Love as a Series of Paintings," in *Symbols & Images*, note 22, p. 109.

10 Gilles Gérard-Arlberg (William Molard's grandson) in "No 6, rue Vercingétorix," *Konstrevy* 2, Stockholm, 1958, pp. 65–68. For a detailed account of Munch's stay in Paris 1896–1897, see Torjusen, op. cit., pp. 194–209.

11 Edvard Munch in a letter to Ragnar Hoppe, dated Oslo, March 3, 1929. See Hoppe, op. cit., p. 18.

12 See Arne Eggum, "The Green Room," in *Edvard Munch*, catalogue, Liljevalchs & Kulturhuset, Stockholm, March–May 1977, pp. 88–90.

13 Strindberg refers to this in an undated letter to Gustaf af Geijerstam, ca. August 19, 1897. See Torsten Eklund, ed., *August Strindbergs brev* (August Strindberg's Letters), 12, Stockholm 1948–1972, no. 3620, p. 143.

14 OKK N 37. Undated note, probably to Jens Thiis, 1932–1933.

15 ". . . Nature is not only what is visible to the eye—it is also the inner visions of the soul—pictures on the other side of the eye." Dated Warnemünde 1907–1908, Munch printed this statement in *Livsfrisens Tilblivelse* (The Genesis of the Frieze of Life), Oslo, undated (1929).

16 From OKK T 2782-ba. Written in Paris in September 1896 at the end of an undated, unfinished draft for a letter (cf. note 8) to Mrs. Valborg Hammer.

17 On the back of an empty portfolio cover with the woodcut *Man's Head in Woman's Hair* on the front (OKK G/t 569-11, illustrated in Torjusen, op. cit., p.190), Munch wrote: "Woodcuts: *Kiss*, *Meteors* (i.e., *Encounter in Space*), *The Girl and the Heart*, etc." This might indicate that Munch wanted to include these prints (all woodcuts) in The Mirror series. A woodcut of *The Kiss*, not mentioned in the 1897 catalogue, is among the extant twelve Mirror prints. In the collection of Munch-museet, there is a colored woodcut of *The Girl and the Heart* (OKK G/t 602-2) and one of *Encounter in Space* (OKK G/t 603-1), both mounted in much the same way as the extant Mirror prints. Munch's inscription on the portfolio cover might, on the other hand, indicate that a portfolio of colored woodcuts was planned, as mentioned in an undated draft for a letter to Meier-Graefe, ca. March 1898 (see Torjusen, op. cit., p.189).

18 Max Dauthendey and Gustaf Uddgren, *Verdensaltet: Det nye sublime i Kunsten* (The Universe: The New Sublimity in Art), Copenhagen, 1893, pp. 33–35.

19 John Boulton Smith in *Frederick Delius & Edvard Munch: Their Friendship and Their Correspondence*, London, 1983, sums up the possible interpretations of this proposed collaboration, referring to Arne Eggum's suggestion that Munch might have considered a portfolio of his prints, Jacobsen poems, and Delius music on interrelated themes, p. 53.

20 From OKK T 2761, ca. 1890.

21 From OKK T 2782-ba, preceding the description referred to in note 16.

22 The book Munch refers to is Helge Rode, *Kongesønner* (King's Sons), Copenhagen, 1896. In Act 1, Telamon, one of the King's sons, says to Helena, daughter of Opties: "Fine threads were spun between us, when our eyes met," p. 26.

23 From OKK N 34, an undated draft for a letter, probably to Jens Thiis, 1932–1933.

THE MIRROR SERIES

The Mirror series is listed according to the sequence in which the prints occur in the 1897 catalogue. Only titles and techniques are mentioned in that catalogue; date and Schiefler number are given here for the sake of clarity. Extant prints from The Mirror, which are reproduced in this book, are marked with an asterisk. The titles are the ones generally used today.

In the Land of Crystals, lithograph, 1897, Sch. 93
Funeral March, lithograph, 1897, Sch. 94
Metabolism, lithograph, 1897, Sch. 95
By the Deathbed, lithograph, 1896, Sch. 72
Death in the Sickroom, lithograph, 1896, Sch. 73
Hands/Lust for Woman, lithograph, 1895, Sch. 35
Lovers in Waves, lithograph, 1896, Sch. 71
Madonna, lithograph, hand-colored, 1895, Sch. 33
*Attraction II, lithograph, hand-colored, 1896, Sch. 66
*Attraction I, lithograph, hand-colored, 1896, Sch. 65
*Jealousy, lithograph, 1896, Sch. 58
Vampire, lithograph, hand-colored, 1895, Sch. 34
*The Urn, lithograph, 1896, Sch. 63
*Madonna, lithograph, 1895, Sch. 33
*Separation II, lithograph, 1896, Sch. 68
The Alley/Carmen, lithograph, 1895, Sch. 36
*The Flower of Love, lithograph, 1896, Sch. 70
The Scream, lithograph, 1895, Sch. 32
Melancholy, woodcut, hand-colored, 1896, Sch. 82
Melancholy, woodcut, 1896, Sch. 82
*The Mirror/Man's Head In Woman's Hair, woodcut,
hand-colored, 1896, detail of Sch. 80a
*Anxiety, woodcut, hand-colored, 1896, Sch. 62

The following three prints were not listed in the 1897 catalogue:
*Vampire, lithograph, 1895, Sch. 34
*Ashes, lithograph, hand-colored, 1896, section of Sch. 69
*The Kiss, woodcut, hand-colored, 1897, Sch. 102 B I

WORDS AND IMAGES

WHAT IS ART -
ART GROWS FROM JOY AND
SORROW - BUT MOSTLY
FROM SORROW -
IT GROWS FROM MAN'S LIFE -
IS ART A DESCRIPTION OF
 THIS LIFE THIS MOVEMENT -
SHALL ONE DEPICT THE DIFFERENT
PLEASURES - THE DIFFERENT
 MISFORTUNES - OR SHALL ONE
ONLY SEE THE FLOWER - WHOSE
NATURE SUBSTANCE AND VIBRATION
 ARE DETERMINED BY
THE JOY AND THE PAIN -

I DO NOT BELIEVE IN AN ART WHICH
HAS NOT FORCED ITS WAY OUT THROUGH
MAN'S NEED TO OPEN HIS HEART -
ALL ART LITERATURE AS WELL AS
MUSIC MUST BE BROUGHT OUT WITH
 ONE'S HEART BLOOD -

48

Blossom of Pain, 1898
Woodcut, 17¾ × 13, OKK

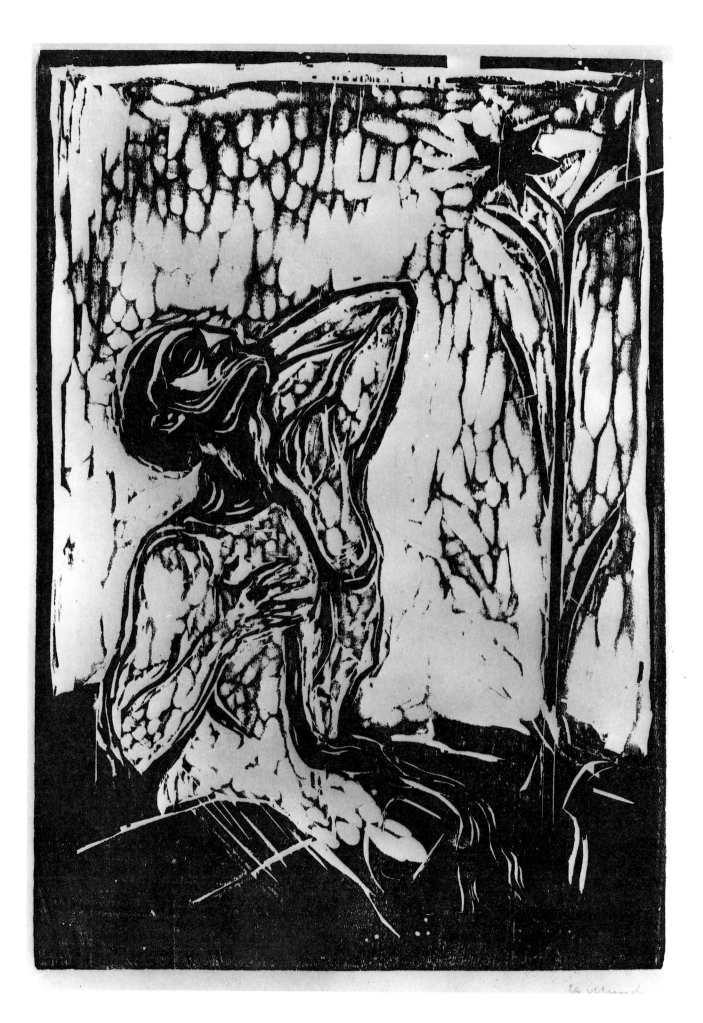

I inherited two of mankind's most dangerous enemies —
the inheritance of consumption and insanity —
disease and madness and death were the black angels
standing by my cradle —

A mother who died early gave me the germ of consumption —
an overly nervous father — pietistically religious bordering on
fanaticism — from an old family — gave me the seeds of
insanity —

From birth — they stood by my side — the angels of
anxiety — sorrow — death followed me outside when I played —
followed me in the spring sun — in the beauty of the summer —
They stood by my side in the evening when I closed my eyes —
and threatened me with death hell and eternal punishment —

And then it often happened that I woke up at night —
and stared in wild terror into the room
Am I in Hell —

The illness followed me through all my childhood and
youth — the germ of consumption placed its blood-red
banner victoriously on the white handkerchief —
my loved ones died one by one —

One Christmas night I lay 13 years old — the blood running
out of my mouth — the fever raging in my veins — the anxiety
screaming inside of me

Now in the next moment you shall stand before the
judgement — and you shall be doomed eternally —

He is saved — but his youth was marked — and doubt —
anxiety and illness — followed him —

— Then he stood almost alone in life — with broken courage —

— He had become accustomed to the thought of not marrying —
He did not have the right either — should he — give life
to a sick home — Should his youth be repeated again?

— As a painter — at least — the Art — became his only goal —

50

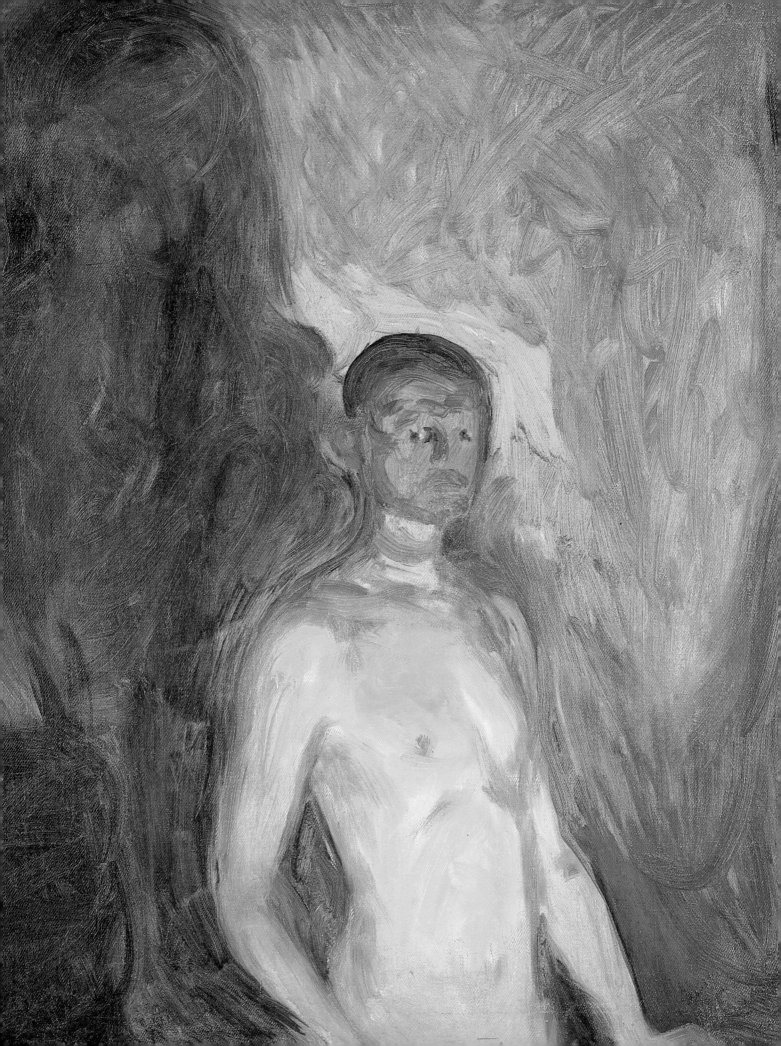

These basically sick years have on the other hand
been decisive for my entire life and my outlook on life —

I therefore do not mean that my art is sick as . . . many
people believe. These are people who do not know the
essence of art nor do they know the history of art
　　When I paint illness and vice it is on the contrary
a healthy release
　　It is a healthy reaction from which one can learn
and live —

Self-portrait with Skeleton Arm, 1895
Lithograph, $17\frac{7}{8} \times 12\frac{1}{2}$, EC

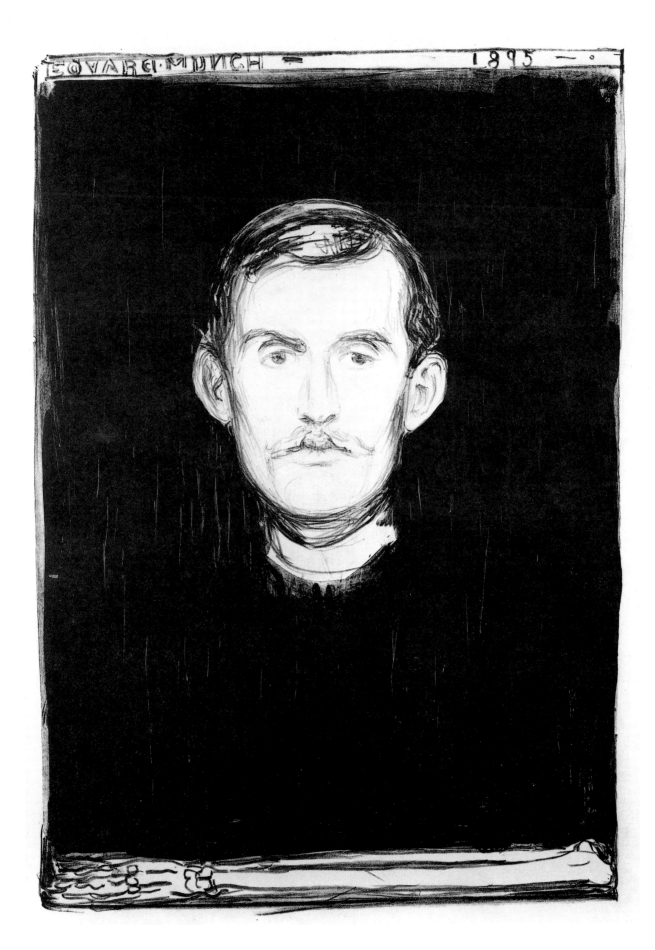

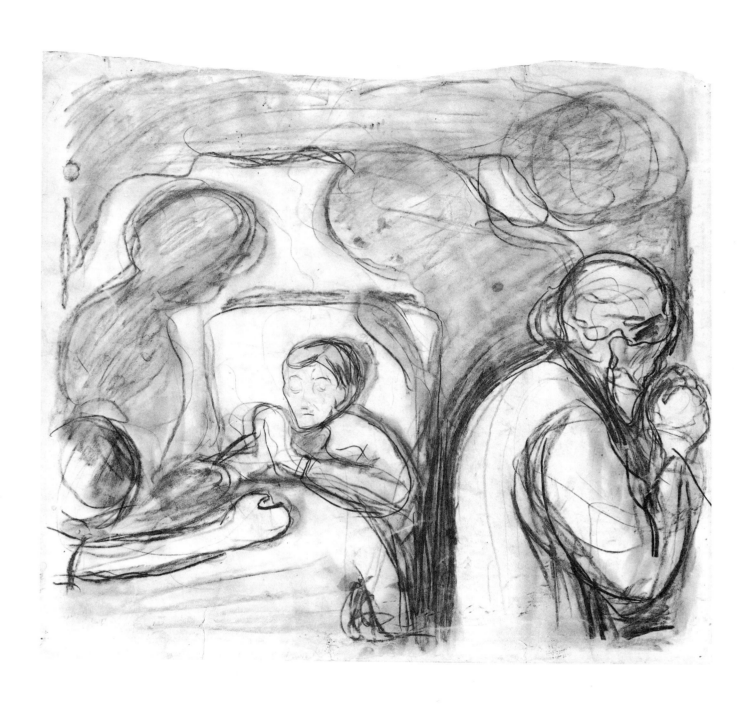

Fever, 1894
Charcoal, 16¾ × 19, OKK

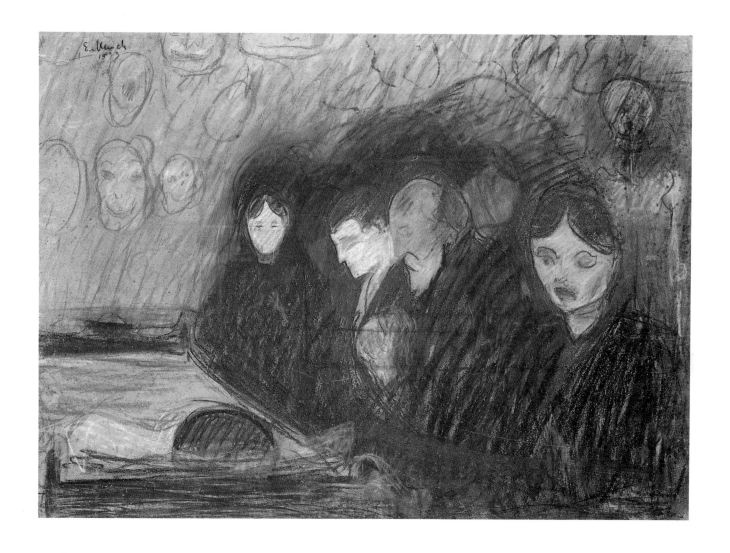

Daddy it is so dark the stuff I am spitting —
Is it my boy —
He took the light and looked at it —
I saw he was hiding something —
The next time he spit on the sheet and he saw it was blood —
It is blood Daddy —
He stroked my head — don't be afraid my boy
I was going to die from consumption — he had heard so much
about it that when one spits blood then one got consumption —
I am walking up to you — his heart beat —

55

By the Deathbed, 1893
Pastel, 23⅝ × 31⁹⁄₁₆, OKK

He crawled out to his father as if to seek protection —
Don't be afraid my boy said the father once more —
His voice was choking with tears —
When you spit blood then you get consumption said Karl —
He coughed again and more blood came up —
Turn yourself to the Lord my boy
Then his father put his hand on his head — and I shall
bless you my boy —
The Lord bless you — may the Lord let His face shine upon you —
May the Lord give you peace —
During the day he had to lay still — not talk —
He stared quietly into space — He knew one could live several
years with consumption — But he couldn't run down on the
street — couldn't play "Einar Tambarskjaelve" with Thoralf —
Toward evening he had higher temperature — and more coughing —
Then he got a mouthful of blood which he spit into the
handkerchief — it became dark red in color — he held it up
in front of him and looked at it — look father and he showed
it to his sister —
She rushed out terrified and brought back the aunt —
There is more coming — they shouted for the doctor —
he ordered ice "don't be afraid my boy".
But he was so afraid
He felt the blood rattle inside the chest — when he
breathed — it felt as if his whole chest was loose — and
as if all his blood would flush out of his mouth —
Jesus Christ Jesus Christ
He folded his hands —
Daddy — I am dying — I cannot die — I dare not —
Jesus Christ —
Don't speak so loudly my boy — I will pray with you —
And he folded his hands over the bed and prayed —
Lord help him if it is your will — don't let him die —
I beg you Almighty God —
We come to you now in our need —
He was interrupted by a new fit of coughing — a new
handkerchief — the blood dyed almost the entire handkerchief —
Jesus help me I am dying — I must not die now
Berte lay stretched out on the other bed praying and
crying loudly and around the bed all the others
some red in the face from crying some white —

Outside chimed the bells they chimed for Christmas —
Inside in the other room stood the decorated Christmas tree —
so exciting and — sad —
Jesus help me —
Do you think I will go to heaven if I die —
That I believe my boy — if you believe —
Do you believe in God god's son and the holy spirit —
Yes he answered but he didn't quite know if he did
he believed there was so much strange in the Bible —
which he had thought of now and again —
Fear seized hold of him — In a few minutes he would be
standing in front of God's judgement seat — he would be
condemned forever forever — he would burn forever in sulphur —
in hell —
Outside in the yard a dog was howling —
He heard an old woman's voice in the kitchen — how is he —
my boy is also sick — it will either be him or my boy —
— because do you hear how the dog barks —
it is not a good omen
Do you want the minister to pray for you in church —
Yes he whispered
He read aloud from the "Comforter"
Those who do not believe shall be condemned but those
who believe shall be saved you will be saved my boy
when you believe
Come unto me all those who suffer and are burdened —
How kindly he bids you — go to him
If only he believed wholly — but there was doubt
If only he had time — only one day — so he could prepare
himself — but he was going to die now —
He felt how his chest was boiling . . .
Just the slightest breathing now filled his mouth with
blood — his aunt put the handkerchief to his mouth —
and hid it quickly —
Occasionally the blood was running onto the sheets —
He lay whispering Jesus — Jesus — I dare not die now —
They all prayed — with folded hands some on their knees —
All over the room whispering was heard Jesus Jesus —
If the Lord did not let you die now — if he let you live
for still some years — would you then promise to love him
and to live according to his commandments —

Yes, yes don't let me die now If only he wouldn't die now
he wouldn't mind having consumption —
The doctor lay on his knees in front of the bed and with
outstretched folded hands he prayed — with a voice unclear
from weeping.
Lord I beg you — I demand you don't let him die today
he is not ready — I implore you have mercy on us let him
live — He will always serve you he has promised me that.
He held up his folded hands I beg you Lord, I implore this
from you — for the sake of the Blood of Jesus Christ
make him well
He had to take salt and suck pieces of ice —
On his chest was put pieces of ice in a cloth —
It did not roll as badly in his chest any more
he became sleepy —
He heard the muted steps of someone walking on tiptoe
he saw — he heard whispering voices
He is fast asleep he heard the doctor — whisper
How wonderful if he got well — He felt him bending over him —
His breathing is calmer — God be praised —
He saw the lamp by the table — his aunt in nightdress
some greenish medicine bottles — with red labels
Above he saw the doctor's smiling face — You have slept
for a long time —
Dawn cast a greyish light into the sick chamber
He lay in the middle of the bed with his hands stretched out
on the eiderdown — and looked straight ahead —
He was in pact with God now — he had promised to serve him —
If he got well and didn't get consumption — he could never
have fun as he used to —
He looked at his brother who ran around with Petra and
Marie . . .
Why then shouldn't he have fun like them — was he any worse
than they —
It was a thought coming from the devil — he folded his hands
and prayed for forgiveness —

By the Deathbed, 1896
Lithograph, 15⅝ × 19¹¹⁄₁₆, OKK

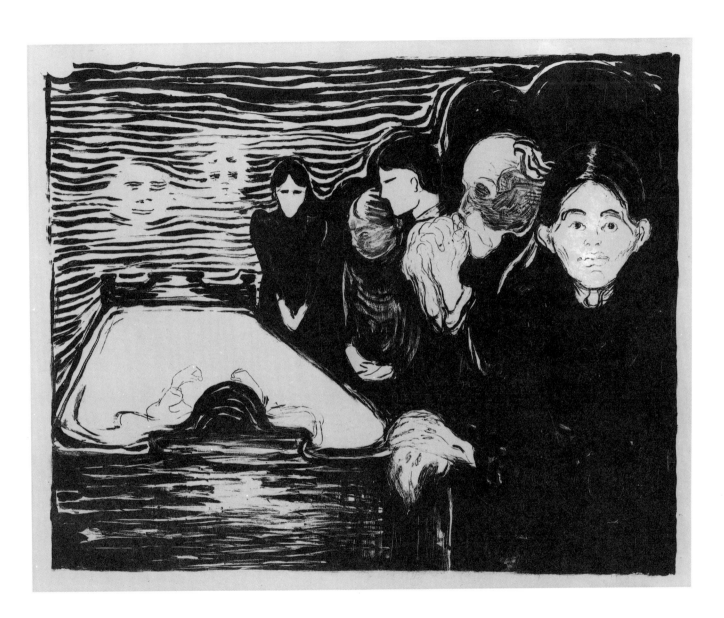

In the same chair as I painted the sick one
I and all my dear ones from my mother on have been
sitting winter after winter longing for the sun —
until death took them away —

I and all my dear ones from my father on have
paced up and down the floor in anxiety fearing for
our sanity

THIS HAS ALL LAID THE FOUNDATION
FOR MY ART AND IT IS THIS
THAT I FELT FROM MY CHILDHOOD
AS A BLOODY INJUSTICE WHICH
 LAID THE FOUNDATION
 FOR THE NEED TO REVOLT
 IN MY ART -

Death in the Sickroom, 1896
Lithograph, 15¾ × 21¼, OKK

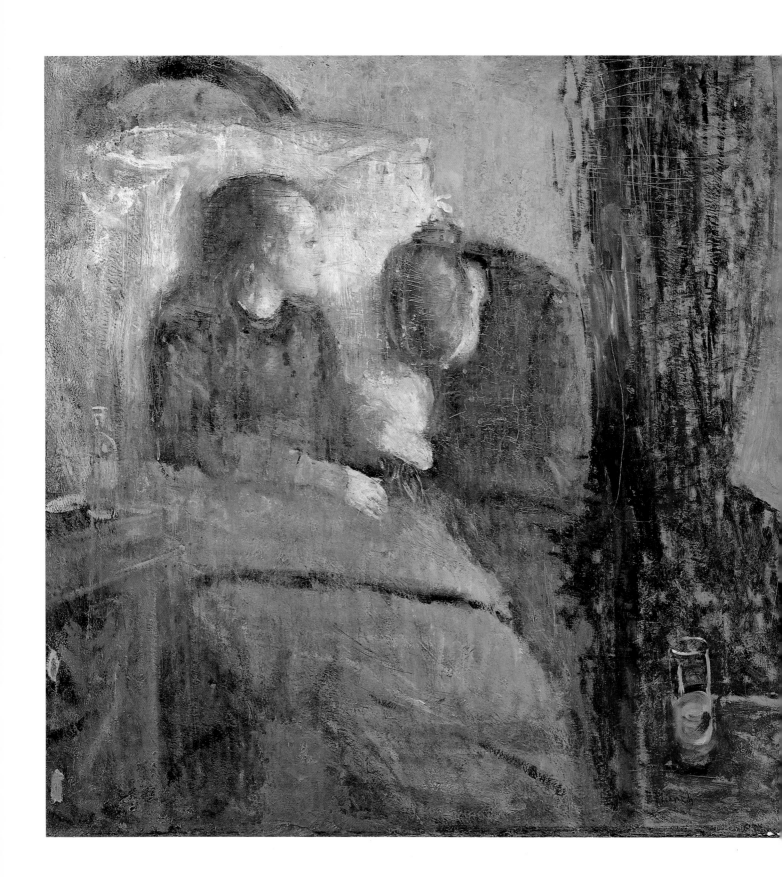

When I saw the sick child The red hair — the pale
face against the white pillow — it gave me an impression
which disappeared during the work —
 — I repainted the picture numerous times — in the course
of a year I scratched it out countless times — I wanted
to catch the first impression — I managed to express much
of this first impression — but gradually I tired out and
the colors became grey — This became the first sick child . . .
— Not until many years later did I bring this picture out
again — and then I painted three new pictures of the sick
child — Here one has managed through the color to catch
the first impression — here the red hair stands strongly
against the white face and the white pillow
 I began later to go directly to the first impression
and then I often painted only from memory — made a
pencil sketch from which I painted
— I then painted only what I remembered and added nothing

The Sick Child, 1885-86
Oil on canvas, 47 × 46⅝, NG

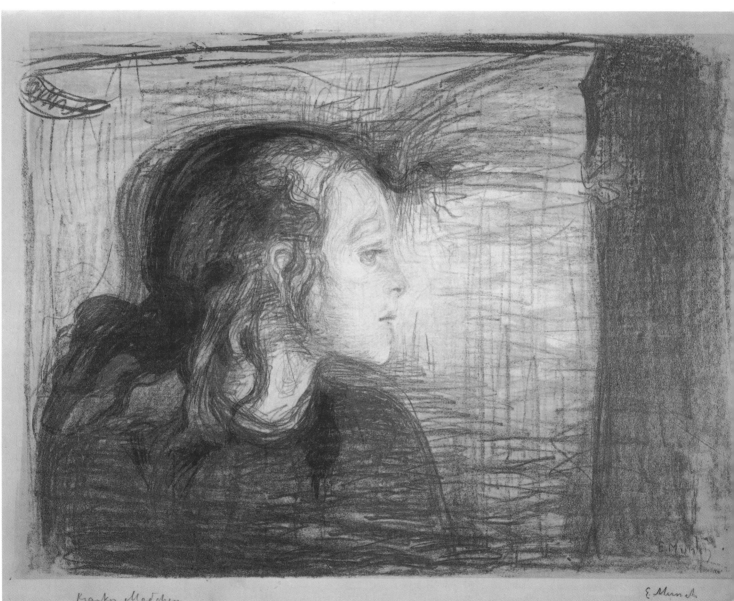

Krankes Mädchen E Munch

IN THE SICK CHILD I BROKE NEW GROUND –
IT WAS A BREAKTHROUGH IN MY ART . –
MOST OF WHAT I LATER HAVE DONE
HAD ITS BIRTH
IN THAT PAINTING .

The Sick Child, 1896
Color lithograph, $16\frac{1}{2} \times 22\frac{3}{8}$, PAS

Nothing perishes — one has no example
of that in nature —
The body which dies — does not disappear —
the human substances disintegrate —
are transformed —
But the spirit where does it go?
Where nobody can say —
to claim that it does not exist
after the death of the body
is just as foolish as to decidedly want
to point out what kind —
or <u>where</u> this spirit will exist —

Metabolism, ca. 1898
India ink, charcoal, gouache, 25½ × 19⁹⁄₁₆ OKK

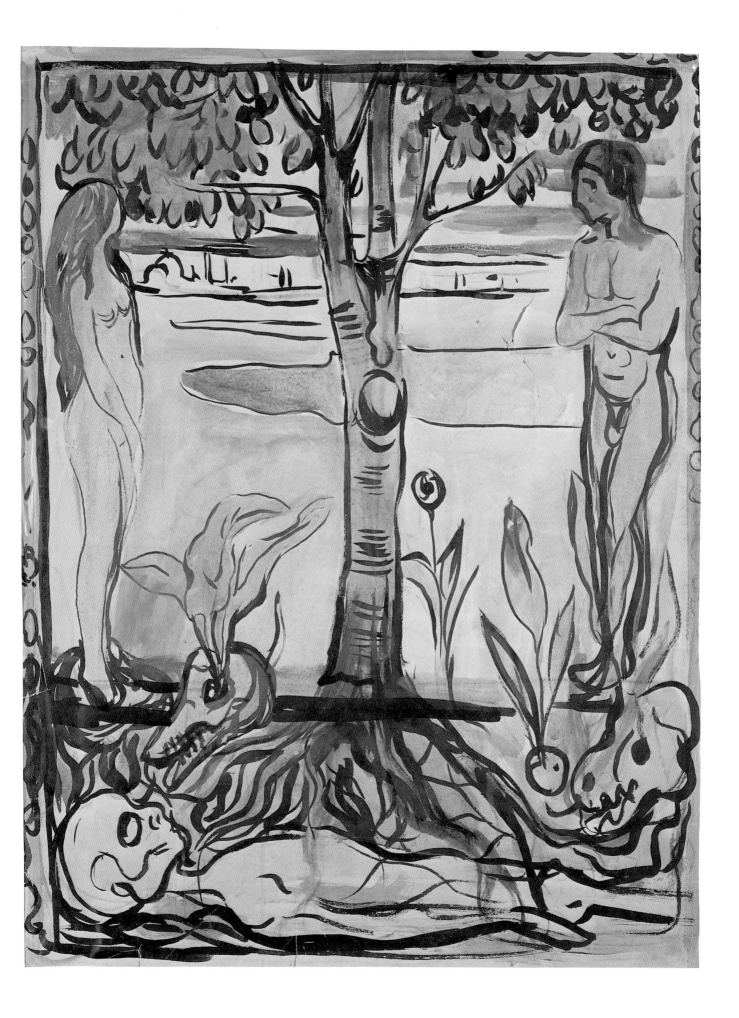

IN THE LIGHT NIGHTS
SHAPES HAVE FANTASTIC TONES –
AT THE BEACH LIE STONES THAT
RESEMBLE TROLLS– THEY MOVE
THERE IS A REFLECTION OF
THE SWAYING MOON

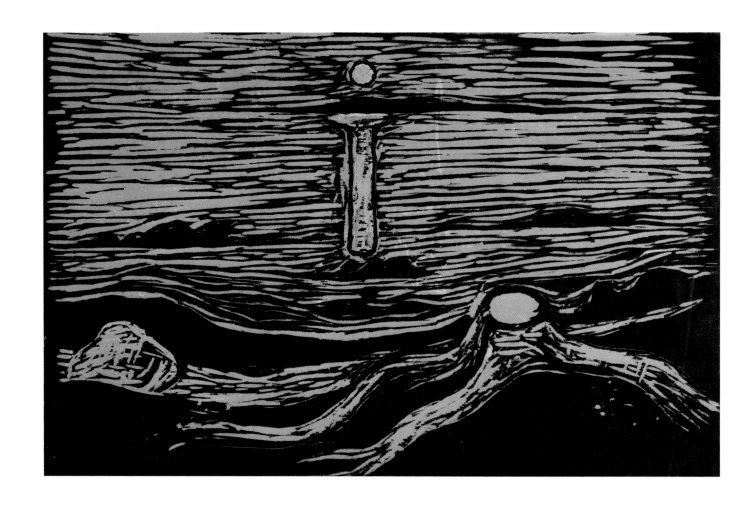

Mystery on the Shore/The Stump, 1899
Color woodcut, 12½ × 22³⁄₁₆, PAS

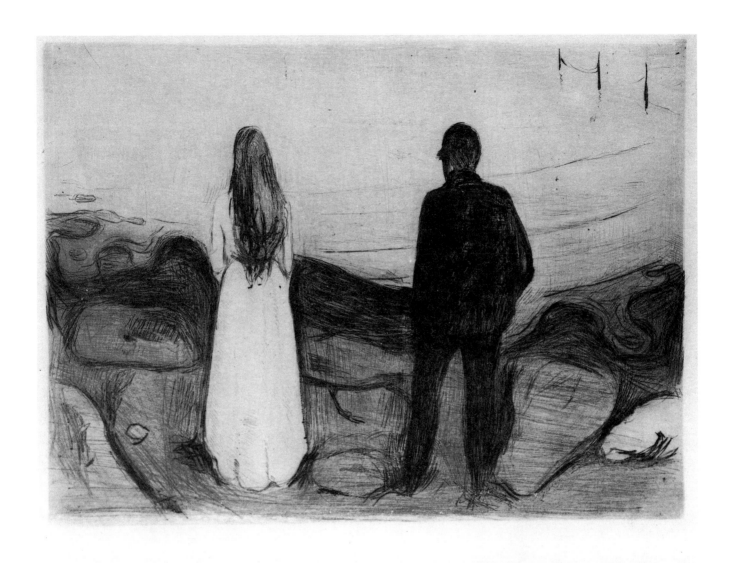

It was evening —
I walked along the sea — there was moonlight
between the clouds
 The stones rose above the water mystically
like the sea people with large white heads and laughed —
some on the beach others down in the water —
and she who walked there by my side looked like a mermaid —
with bright eyes and her flowing hair shines like gold
in the light from the horizon —

69

Two People/The Solitary Ones, 1895
Drypoint and roulette, $6\frac{1}{8} \times 8\frac{3}{8}$, EC

I GIVE HER THE LIGHT SUMMERNIGHT'S

SOFT BEAUTY– OVER HER I POUR

THE SPLENDOR OF THE VANISHING SUN –

 OVER HER HAIR– OVER HER

FACE OVER HER WHITE DRESS –

 SHINING GOLD –

I PLACE HER AGAINST THE BLUE

 OF THE BOOMING SEA –

 WITH THE SINUOUS

SNAKE LIKE CURVES OF THE SHORELINE

70

Young Girl on the Shore/The Solitary One, 1896
Color mezzotint, 11⁵⁄₁₆ × 8⁹⁄₁₆, PAS

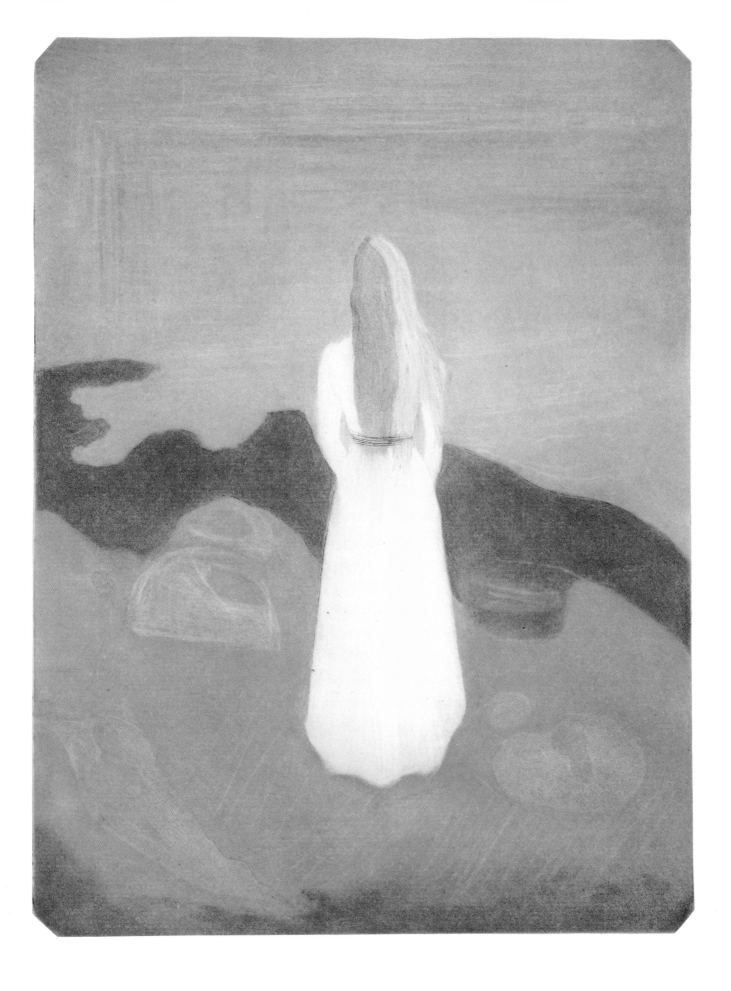

Your eyes are as big as half the heaven
when I stand close to you and your hair has golden dust
and the mouth I do not see — see only that you smile

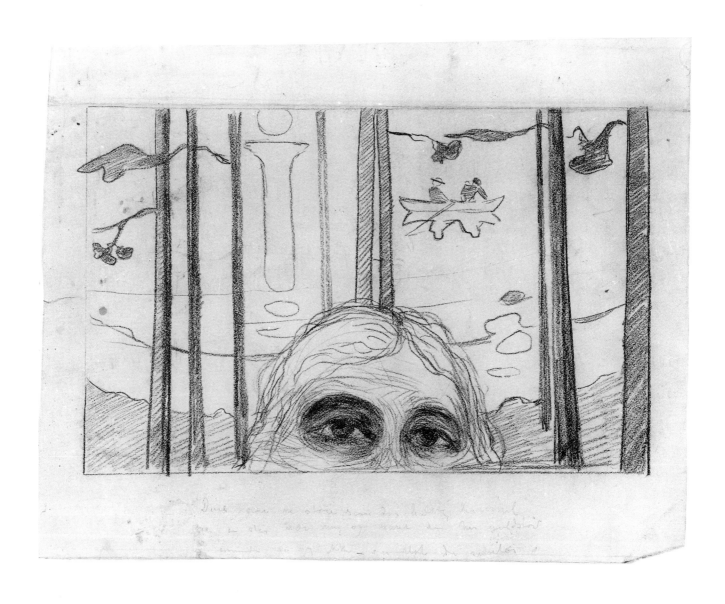

The Voice/Eyes, 1893-1896
Pencil, crayon, 16³/₈ × 19¹¹/₁₆, OKK

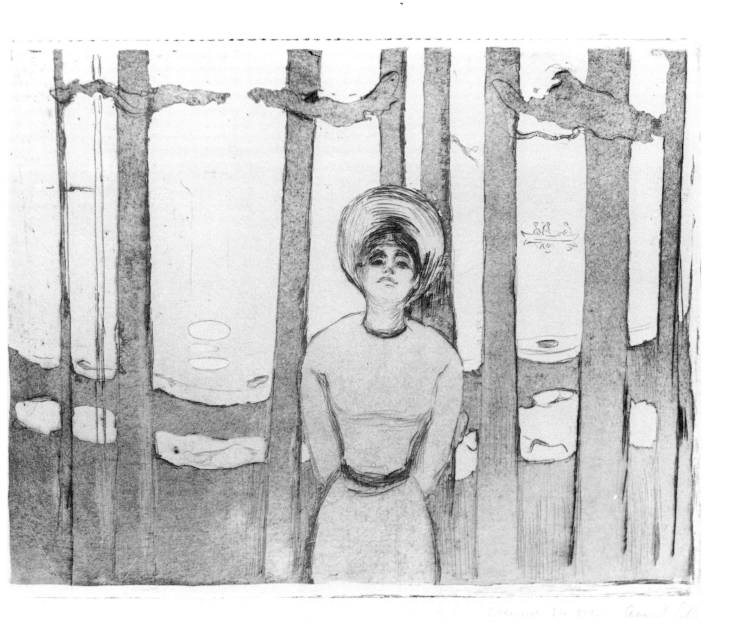

Stand upon that hillock so I can look into your eyes —
You are taller than I — I stand upon the hillock, so I can
look into your eyes —

How pale you are in the moonlight and how dark your eyes are —
they are so big that they cover half the sky —

I can hardly see your features — but I can dimly see your
white teeth when you smile —

73

The Voice, 1895
Aquatint, drypoint, 9³⁄₈ × 12³⁄₈, EC

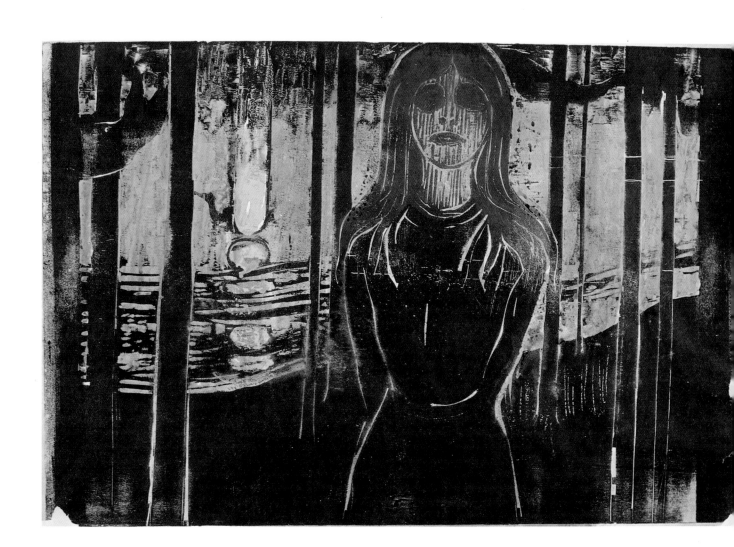

WHEN LOVE GREW!
NATURE GAVE YOU OF HER BEAUTY
AND YOU BECAME MORE BEAUTIFUL
THE SUMMERNIGHT CAST GOLD
OVER YOUR FACE AND YOUR HAIR —
ONLY YOUR EYES — WERE DARK —
AND SPARKLED WITH A MYSTERIOUS
GLOW — AND NATURE BECAME MORE
BEAUTIFUL BECAUSE OF YOU —
 THROUGH MY RETINA
WHICH HAD VANISHED FROM YOUR BEAUTY —
 I SAW THE SEA BECOME VASTER —
THE WAVES SOFTER —
 THE FOREST A DARKER GREEN —

The Voice, 1896
Color woodcut, hand colored, 15 × 22³/₁₆, OKK

They walked across the floor to the open window
leaning out looking down in that garden It was chilly out there
— The trees stood like big dark masses against the air
It is _too_ lovely — look there she pointed along the water
between the trees

Oh and up there is the moon — one is barely aware of it —
it will emerge later

I am so fond of the darkness — I cannot stand the light —
it ought to be just like this evening when the moon is
behind the clouds — it is so mysterious — The light is so
indiscreet

It is like this with me she said after a while — on evenings
like this I could do anything — something terribly wrong
Her eyes were big and veiled in the twilight . . .

It was as if she meant something with it — he had a
premonition that something was going to happen —

Starry Night, 1893
Oil on canvas, 53⅛ × 55⅛, JPGM

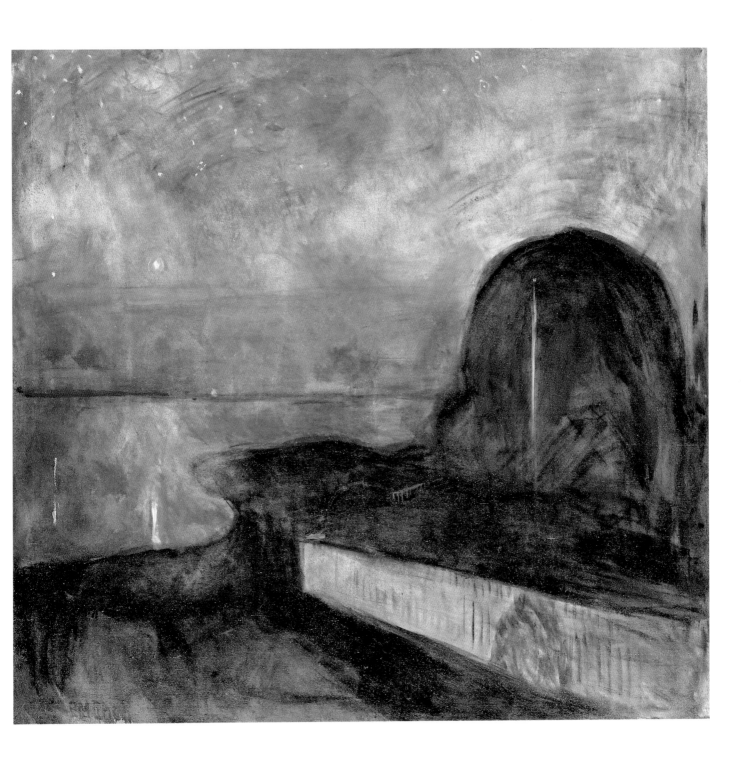

WHEN WE STOOD FACING EACH
OTHER AND YOUR EYES
LOOKED INTO MY EYES
 THEN I FELT
AS IF INVISIBLE
THREADS LED FROM
 YOUR EYES INTO
 MY EYES AND
TIED OUR HEARTS
TOGETHER

78

Attraction I, 1896
Lithograph, hand colored, 16 × 13⅝, HUAM

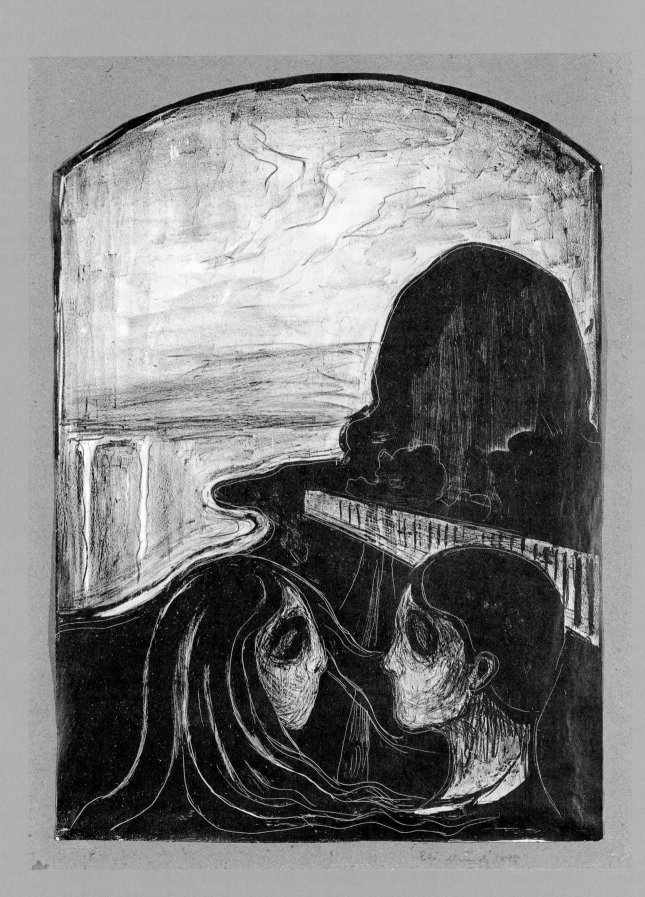

WHEN WE STAND LIKE THIS -
AND MY EYES LOOK
INTO YOUR BIG EYES -
IN THE PALE MOONLIGHT -
DO YOU KNOW THEN - THAT
FINE HANDS BRAID INVISIBLE THREADS -
WHICH ARE TIED AROUND MY HEART -
ARE LED FROM MY EYES
THROUGH YOUR BIG DARK EYES -
AROUND YOUR HEART -
YOUR EYES ARE SO BIG NOW
THAT YOU ARE SO CLOSE TO ME -
THEY ARE LIKE
TWO BIG DARK HEAVENS -

Attraction II, 1896
Lithograph, hand colored, 14⁷⁄₈ × 24, HUAM

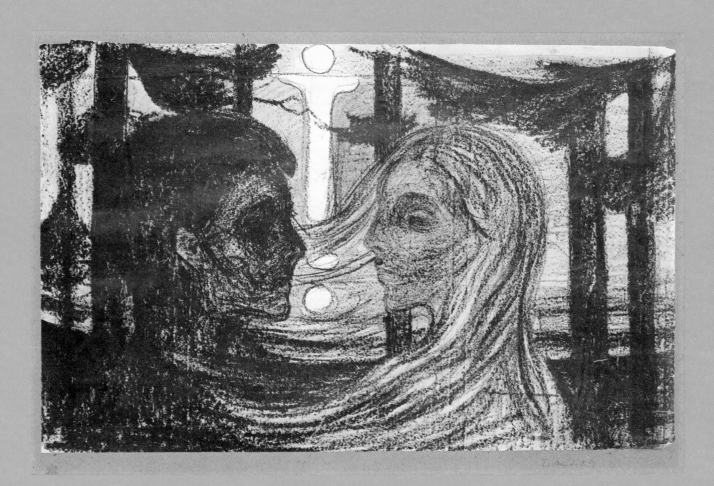

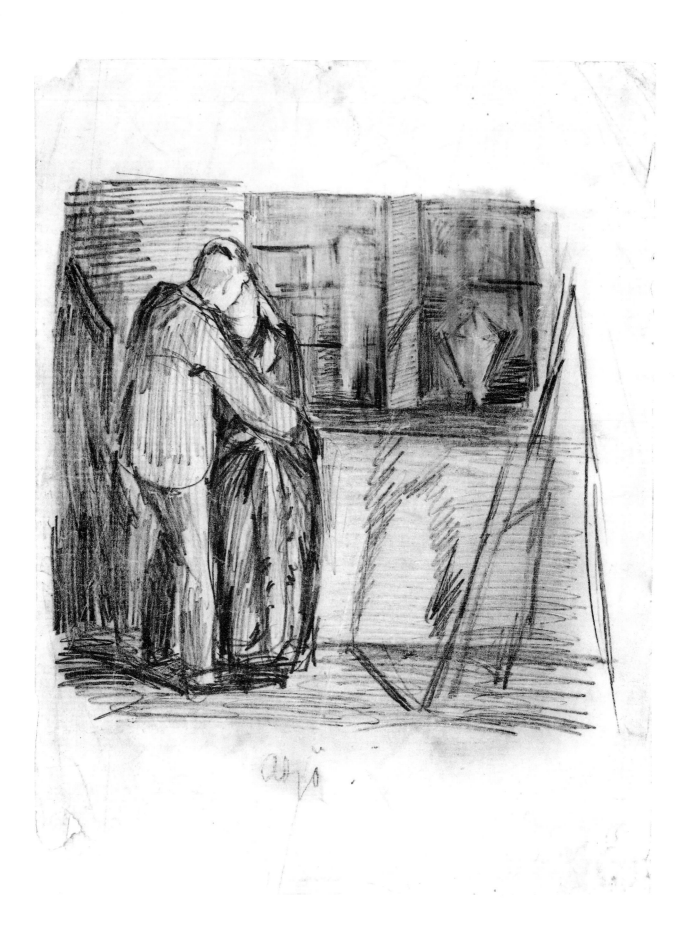

I have to leave soon she said it is getting so dark —
He stood for a while without knowing what he should say or do —
 Then he held out his hand —
 Adieu —
 Adieu —
 She walked away with her head bent — he remained on the same
spot looking helplessly after her
 Then she suddenly turned around and walked up to him
Oh — it is so painful — so painful to have to separate
 She took him once more by the hand He took her carefully
around her waist She stretched up toward him — closer to
him —
 And he did not see any more, did not think, did not hear —
it was as if something wonderful had caught hold of him
 He felt warm lips nearby his neck — a wet cheek against
his — his lips sank softly into hers
 He opened his eyes and encountered two big dark eyes which
looked into his
 He wanted to cry but also to rejoice
 It was over
 She took him by the hand and whispered adieu then —
so sadly and softly —

Adieu/The Kiss, 1889-90
Pencil, 10⅝ × 8¹/₁₆, OKK

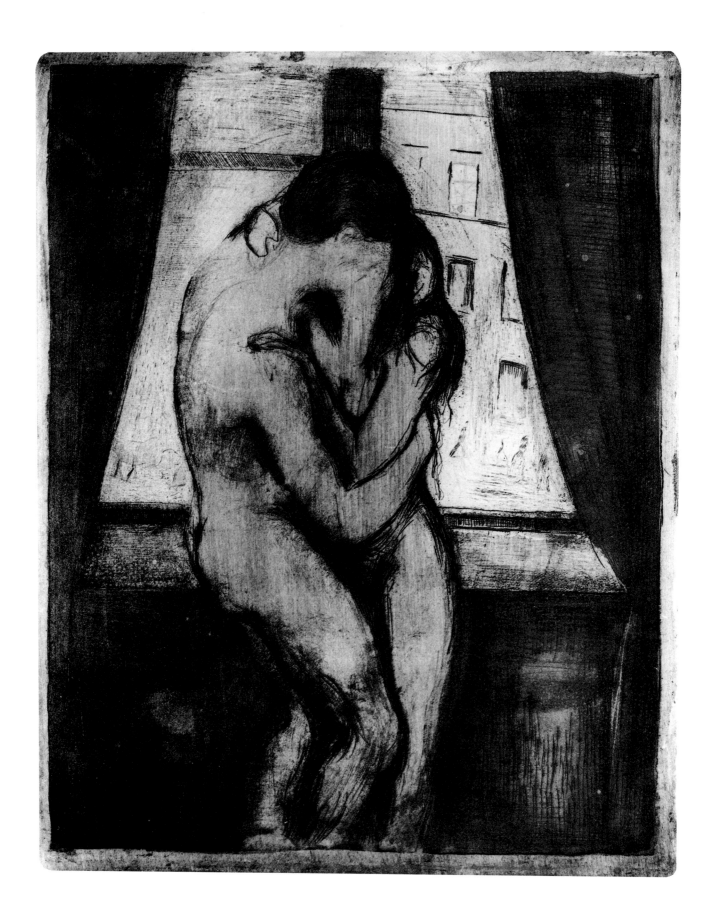

THE KISS -
IT RAINED A WARM RAIN
I TOOK HER AROUND
THE WAIST - SHE WALKS
 SLOWLY AFTER -
TWO BIG EYES AGAINST
 MINE - A WET
CHEEK AGAINST MINE
MY LIPS SANK INTO HERS
THE TREES AND THE AIR AND
ALL THE EARTH VANISHED
AND I LOOKED INTO A NEW
 WORLD - I NEVER
 BEFORE HAD KNOWN

The Kiss, 1895
Etching, drypoint, aquatint, $13\frac{5}{8} \times 10\frac{7}{8}$, EC

THE KISS
TWO BURNING LIPS AGAINST MINE
HEAVEN AND **EARTH** VANISHED
AND TWO BLACK EYES LOOKED
INTO MINE —

The Kiss, 1897
Woodcut, hand colored, 17½ × 14¾, HUAM

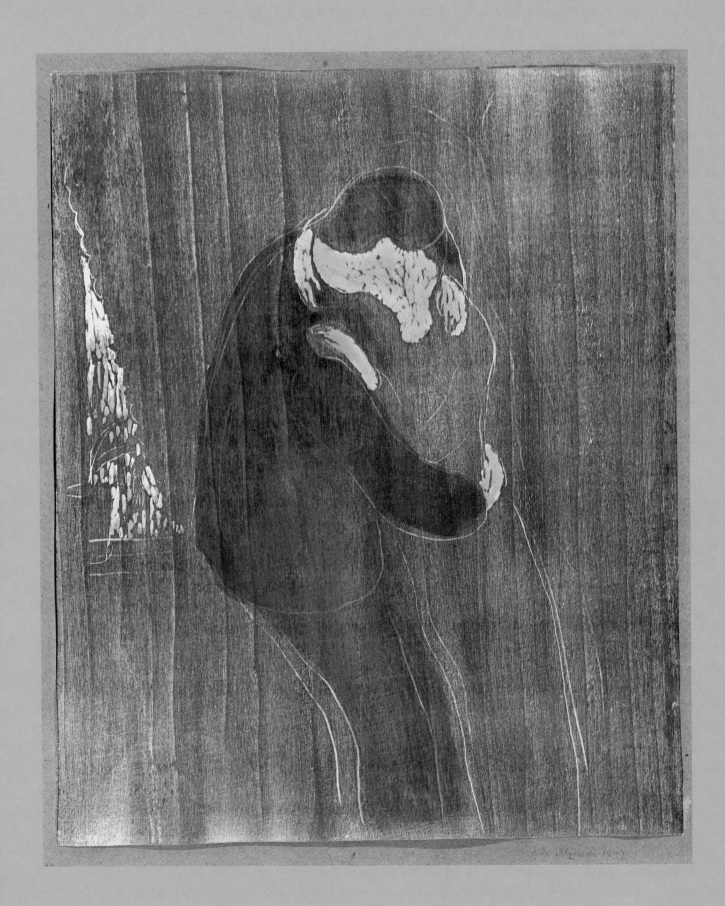

YOUR PROFILE IS A MADONNA'S....

Study for Madonna, 1893-94
Charcoal, pencil, 29$\frac{1}{16}$ × 23$\frac{9}{16}$, OKK

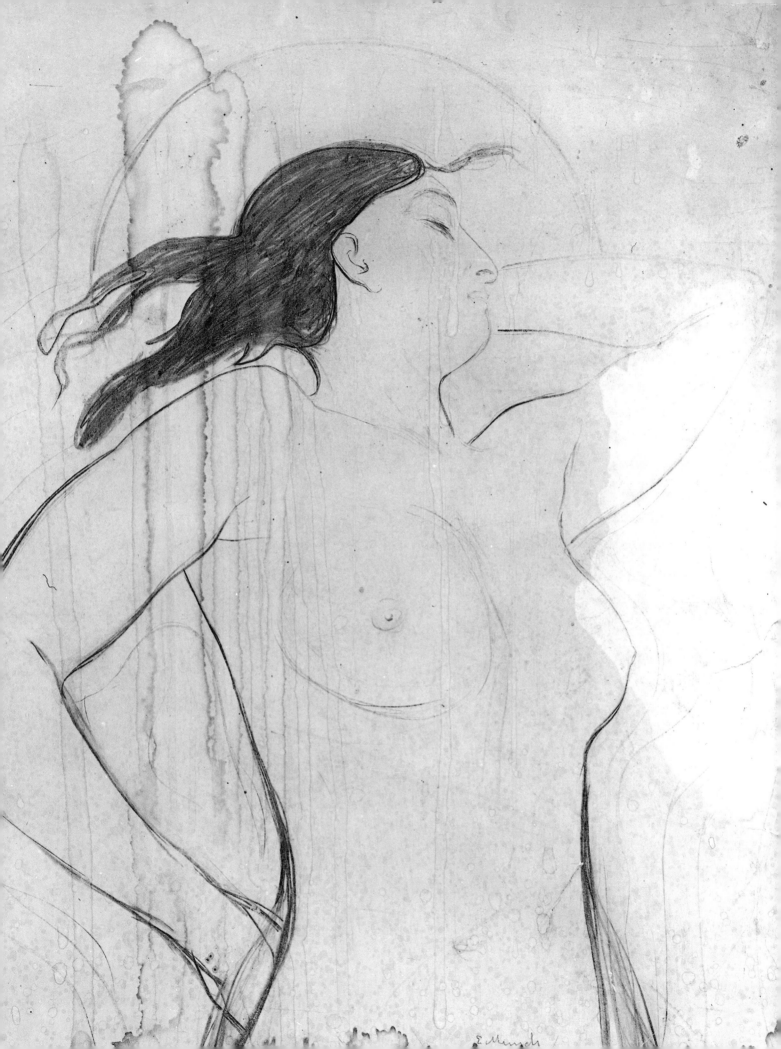

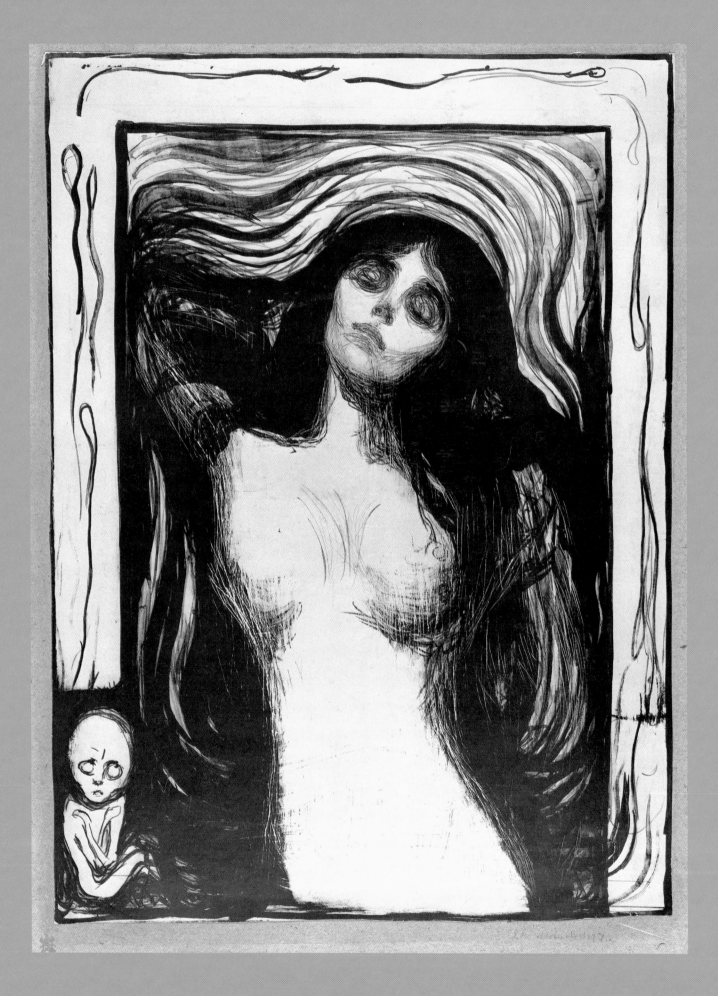

THE PALE BEAUTY OF A MADONNA
THE MOMENT HAS COME WHEN
LIFE STREAMS THROUGH HER—
WHERE THE CHAIN IS CONNECTED FROM
THOUSANDS OF YEARS —
A THOUSAND YEARS AGO —
LIFE IS BORN ONLY TO BE—
BORN AGAIN AND DIE —
THE ACT OF CREATION
IN HER MOUTH IS PAIN —
IN ONE OF THE CORNERS OF HER
MOUTH SITS A SPECTRE OF DEATH —
IN HER TWO LIPS
THE JOY OF LIFE —

Madonna, 1895
Lithograph, 23⁵⁄₁₆ × 17³⁄₈, HUAM

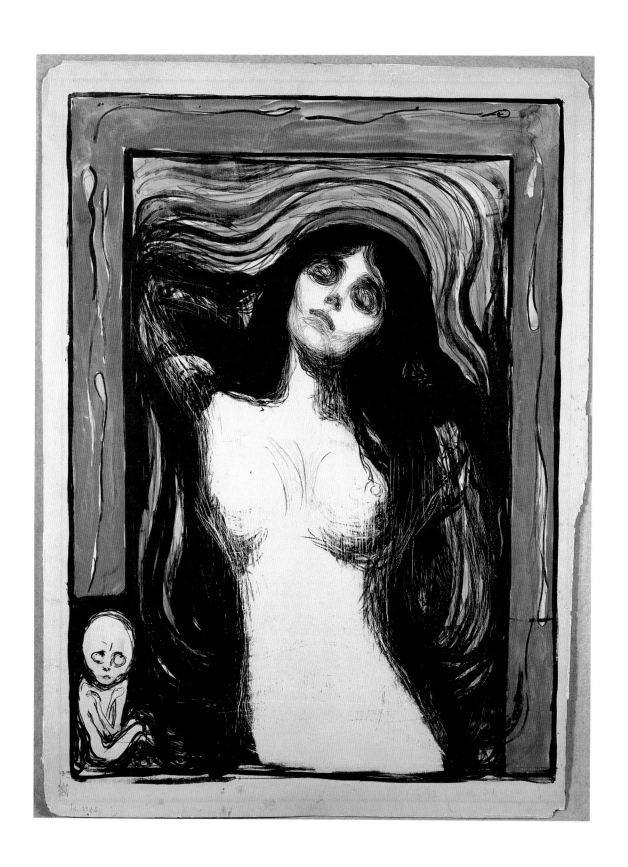

Madonna, 1895
Lithograph, hand colored, 23⅝ × 17⁵⁄₁₆, EC

THE WOMAN WHO GIVES HERSELF
AWAY – AND OBTAINS
A MADONNA'S PAINFUL BEAUTY –

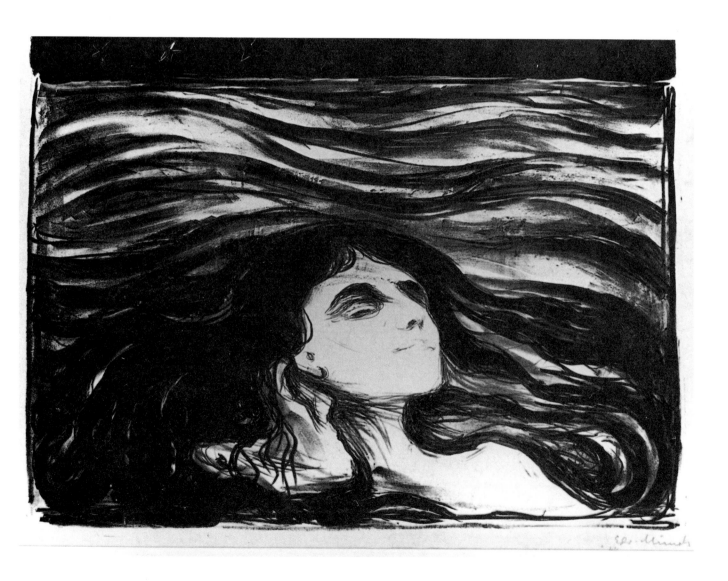

Lovers in Waves, 1896
Lithograph, 12³⁄₁₆ × 16³⁄₈, EC

Mennesken glider om det ansigt
der puld ud al jordlivs skjønhed og smerte.

Disse læber ere som de varbred røse
og blodfyldte som den kummerens frugt
– De glider forbi hinanden som i smerte
et ligs smil —————— Thi

Nu knuges kjeden der binder slægter
til slægter ——

Som et legeme glider en — ud på
et stort hav — på lange bølger du skyfte
i from for dybmold og klarhed

Moonlight glides across your face
which [is] filled with all the world's beauty — and pain.
Your lips are like two ruby red worms
and filled with blood as in the crimson fruit
 — they slide apart as in pain
the smile of a corpse ———— For
Now the chain is bound which ties generations
to generations ————
 Like one — body we glide out upon
a vast ocean — on long waves which change in color
from deep violet to blood red

Lovers in Waves, ca. 1912-15
Watercolor, gouache, India ink, pencil, 24³⁄₈ × 18¹⁄₂, OKK

Human destinies
are like planets —
which move in space
and cross
each others' orbits —
— A pair of stars
that are destined
for each other
barely touch one another
and then vanish
each in their direction
in the vast space —
Among the millions
of stars there are
only few
whose courses coincide —
so as to become
absorbed completely
in one another
in shining flames . . .

96

Decorative Design, 1897
Color lithograph, 11⅝ × 14¹⁵⁄₁₆, OKK

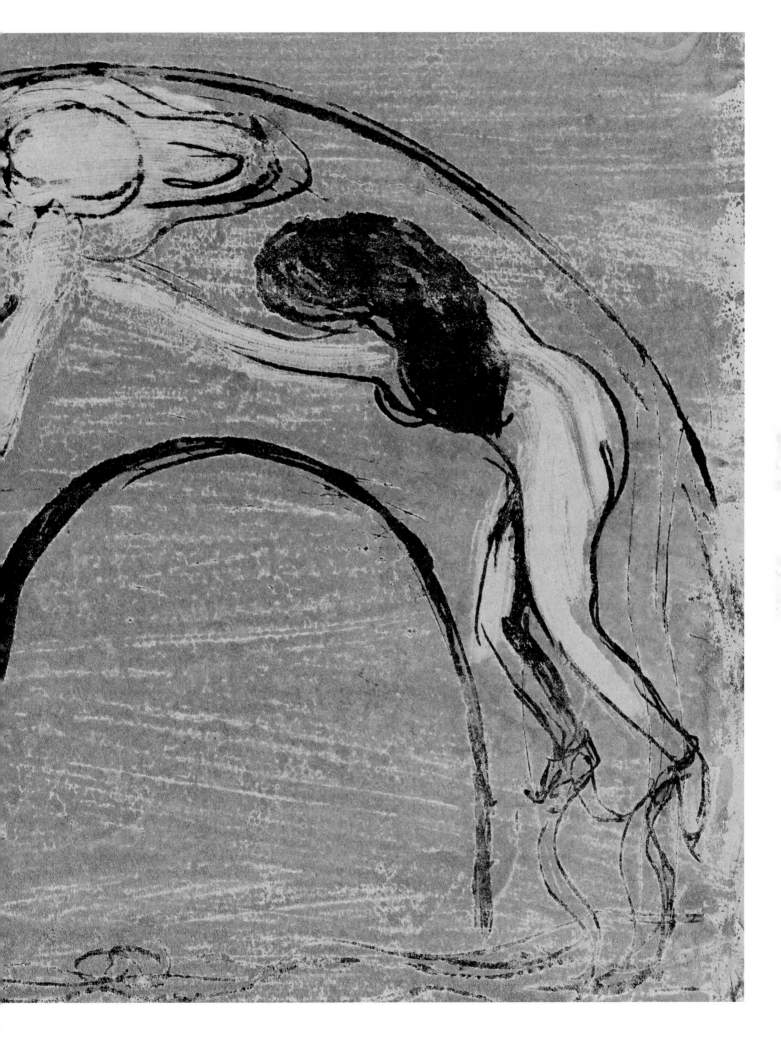

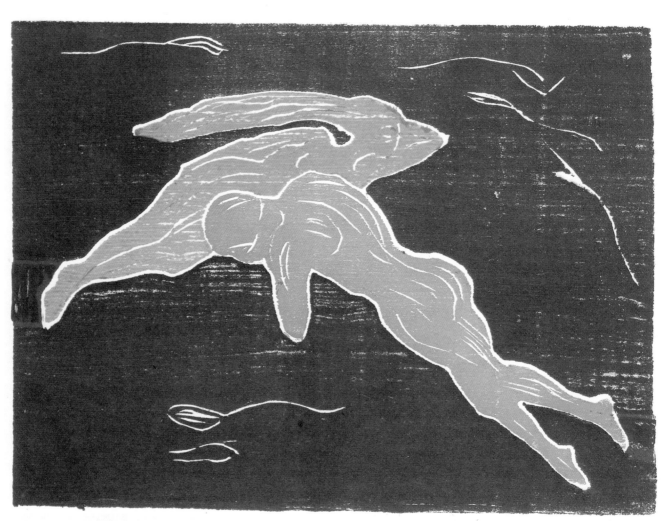

HUMAN DESTINIES
ARE LIKE THE PLANETS
THEY MEET IN
SPACE ONLY TO
DISAPPEAR ONCE
AGAIN ...

Encounter in Space, 1899
Color woodcut, 7¾ × 9⅞, PAS

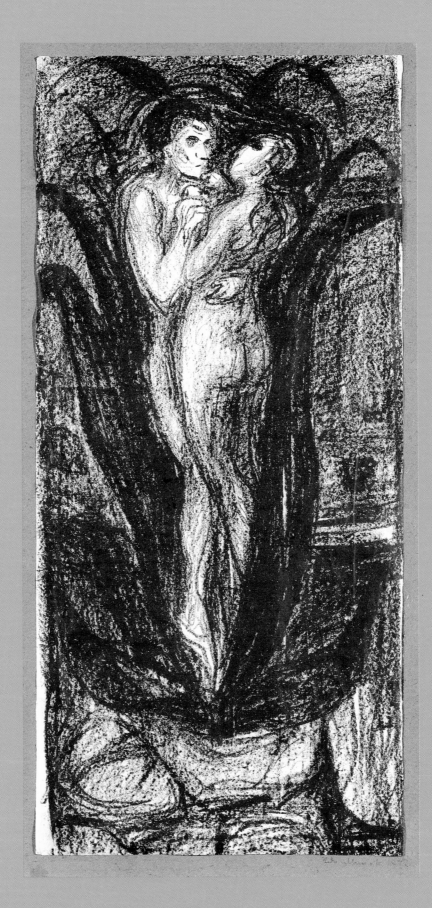

ONLY FEW MEET IN THE ONE
TREMENDOUS FLAME –
WHERE THEY BOTH CAN
BE COMPLETELY ONE

The Flower of Love, 1896
Lithograph, $22^{15}/_{16} \times 10^{7}/_{8}$, HUAM

Intermezzo

He sat with the arm around her waist — her head was so
near him — it was so strange to have her eyes her mouth
her breast so close against him —
He looked at each eyelash — looked at the greenish
nuances in the eyeball — which had the transparency
of the sea — the pupil was large in the semi-darkness —
He touched her mouth with his finger — the soft flesh
of her lips yielded to his touch — and the lips moved into
a smile while he felt the big blue-grey eyes
rest upon him — He studied her brooch which reflected
red lights — he felt it with his trembling fingers
And he lay his head against her breast — he felt the
blood rush in her veins — he listened to her heartbeat —
He buried his face in her lap he felt two burning lips
in the back of his neck — it gave him a freezing sensation
through his body — a freezing lust — Then he pressed her
forcefully toward him.

Vampire, 1895
Lithograph, 14⁷⁄₈ × 21⁷⁄₁₆, HUAM

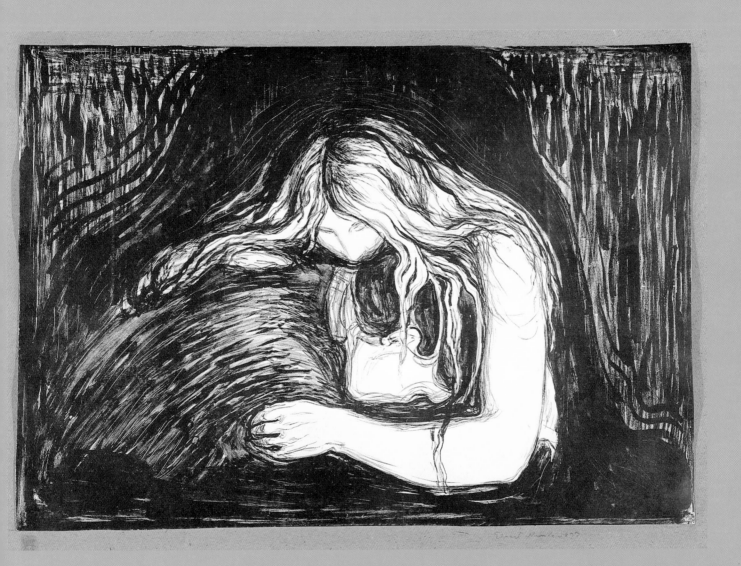

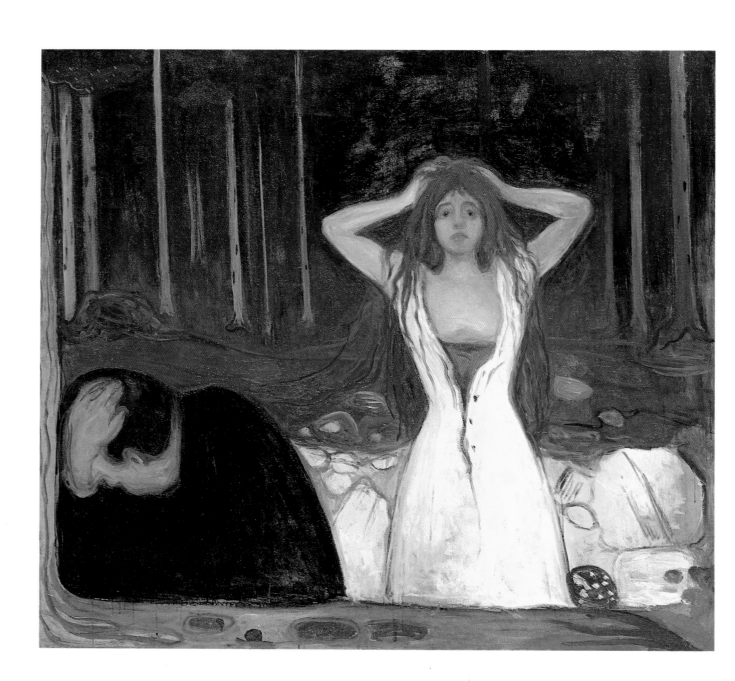

Right away she had gotten something hard in her
expression — she loosened her hair — let it fall
down over her shoulders — then threw it back with an
impatient movement — she was so beautiful now —
looked like an offended queen

She had never before stayed as long as this with
him — he begged her not to leave — he was more ardent
than ever before — he wanted to had to embrace her
again feel her kisses again — when they got up
the glow was once more extinct —

She stood straight and fixed her hair
with the posture of a queen

There was something in her expression that made
him feel fearful — he did not know what it was —

Ashes, 1894
Oil on canvas, 47$^{7}/_{16}$ × 55$^{1}/_{2}$, NG

I FELT OUR LOVE
LYING ON
THE GROUND LIKE A
HEAP OF ASHES

Ashes, 1896
Lithograph, hand colored, 11¾ × 16⁷⁄₁₆, HUAM

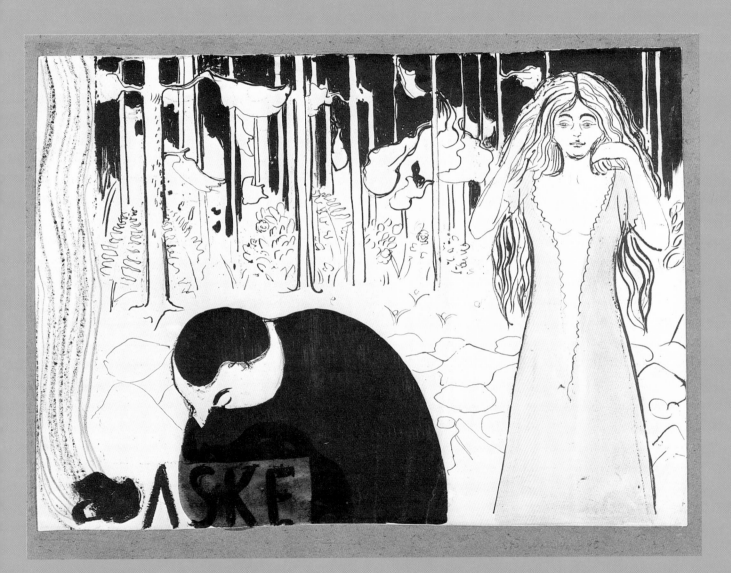

Thus she is leaving him
— who still does not comprehend
but as in a dream feels
her becoming distant
— He is left in the middle
of the blood-red flowers —
in the deep blue shadows of the evening
　　He cannot quite understand
　　how it came to happen —

Separation I, 1896
Lithograph, 18⅛ × 22¼, EC

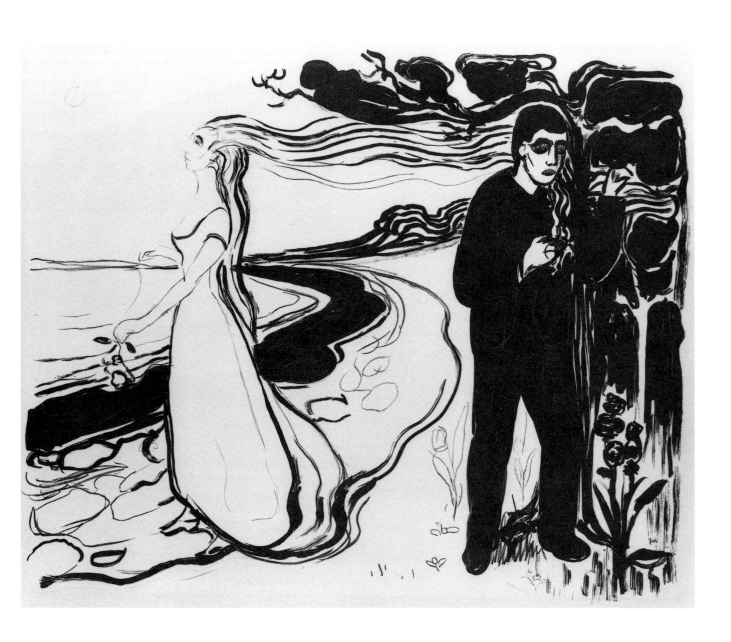

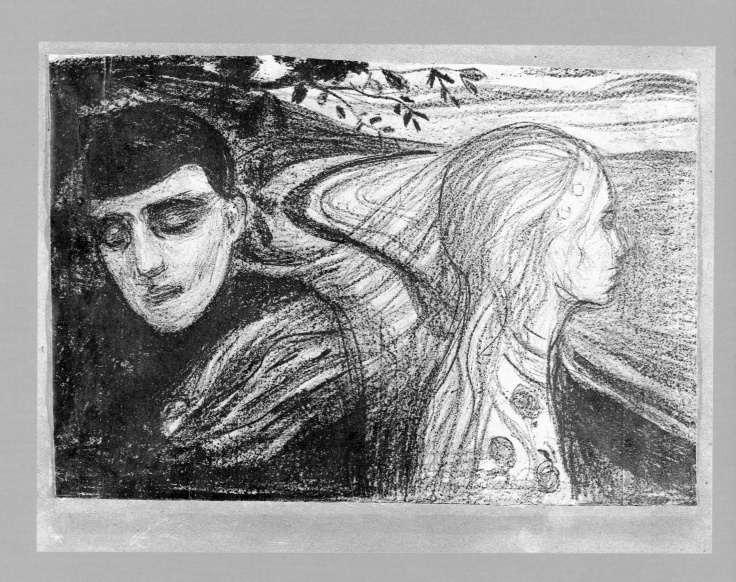

WHEN YOU LEFT ME OVER
THE OCEAN IT WAS AS IF
FINE THREADS STILL UNI-
TED US IT TORE AS
IN A WOUND

Separation II, 1896
Lithograph, 15½ × 23¾, HUAM

Darkness descended deep-violet over the entire earth —
I sat under a tree — whose leaves began to yellow
to wilt — she had been sitting next to me — she had
bent her head over mine — her blood-red hair had entwined
itself around me — it had twisted itself around me like
blood-red snakes — its finest threads had entangled
themselves in my heart — then she had risen — I do not
know why — slowly she moved away toward the sea — farther
and farther away — then the strange thing had occurred —
I felt as if there were invisible threads between us —
I felt as if invisible threads of hair still entwined me —
and thus when she completely disappeared there across the sea —
then I still felt how it hurt there where my heart was bleeding —
because the threads could not be torn

112

Separation/Melancholy, 1896-98
Pencil, 11⅝ × 7½, OKK

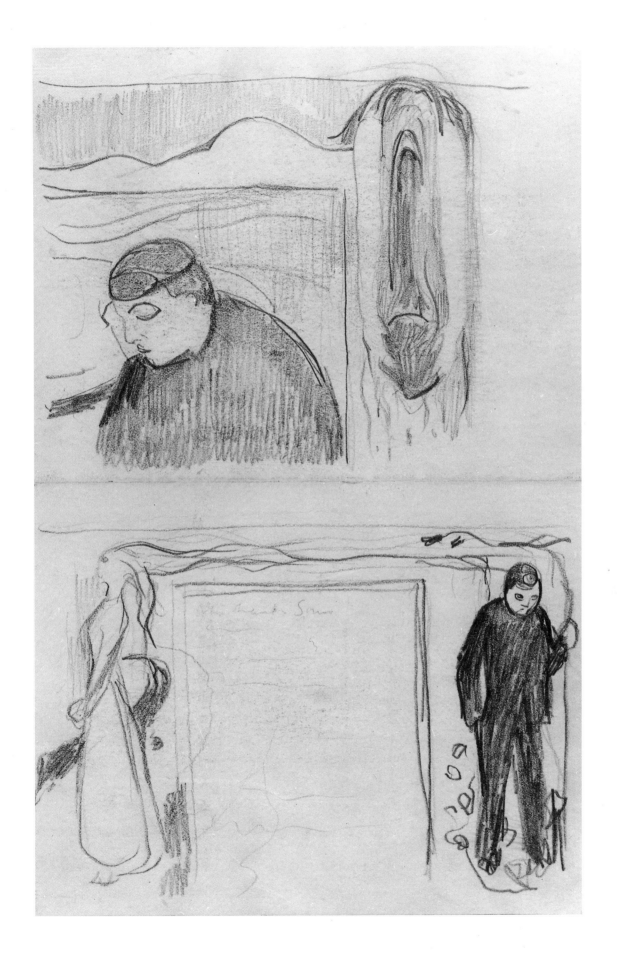

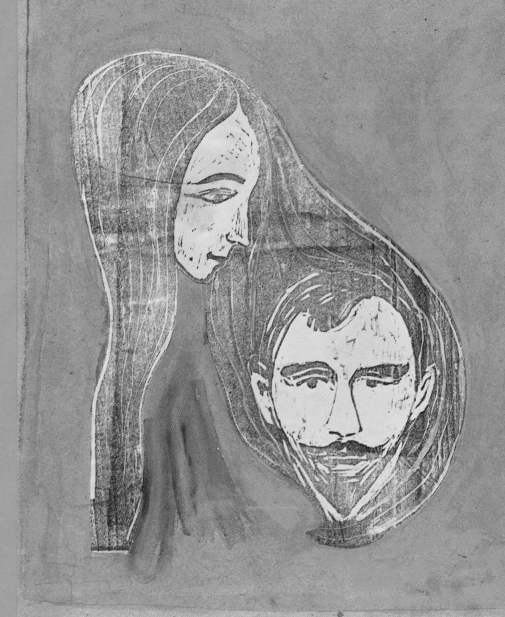

SPEILET · ANDEN DEL. 1897

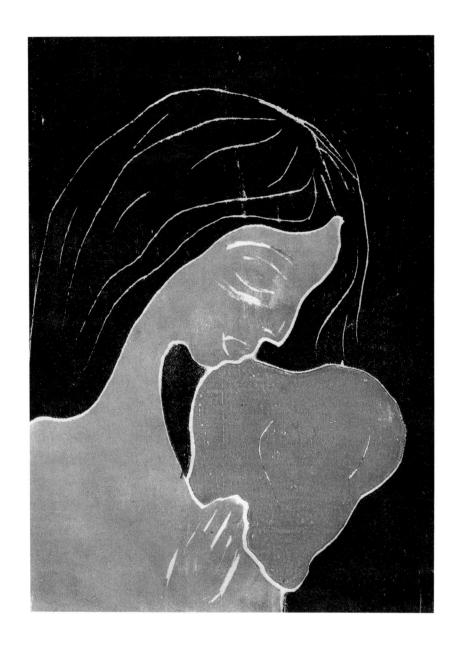

...FINE THREADS OF HER HAIR
ARE STILL ATTACHED TO HIS
HEART — IT BLEEDS — AND HURTS
AS AN ETERNALLY OPEN WOUND

The Mirror/Man's Head in Woman's Hair, 1896
Woodcut, hand colored, 24¼ × 23⅝, HUAM

The Girl and the Heart, 1899
Color woodcut, 9¹³⁄₁₆ × 7³⁄₈, PAS

A mysterious stare the jealous one's/in these two piercing eyes/are concentrated as/in a crystal many mirror/images. — The stare is/searching interested/hateful and amor/ous an essence/of her whom they/all have in common

116

A Mysterious Stare, ca. 1912-15
Colored crayon, 25¹¹⁄₁₆ × 18¹¹⁄₁₆, OKK

Jealousy, 1896
Lithograph, 18¼ × 22⅛, HUAM

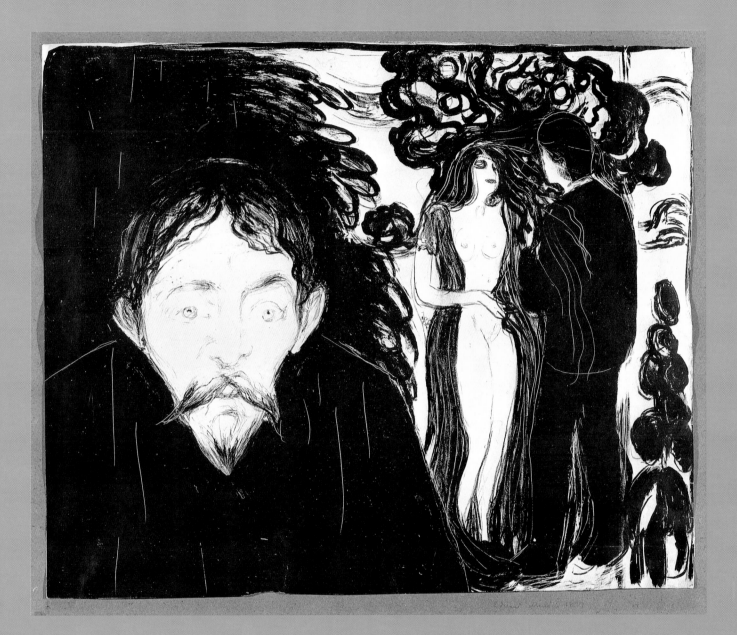

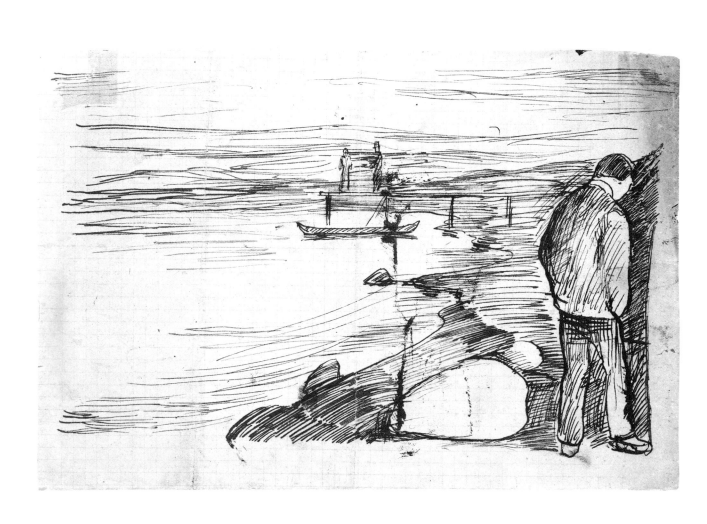

One evening I walked alone by the water —
it sighed and swished between the stones —
there were long grey clouds on the horizon —
it was as if everything had died out — as if in
another world — a landscape of death —
but then there was life over there by the wharf —
there was a man and a woman — and still another man
came — with oars on his shoulders — and the boat was
in place down there — ready to leave —
 She looks like her — I felt as if a sting
in my breast — was she here now — but I know she is
far away — and yet and yet those are her movements —
she used to stand that way — her arms on her hips —
God — heavenly father — have mercy on me — it must not
be her —

Evening/Melancholy, 1891
India ink, 5⁵/₁₆ × 8¼, OKK

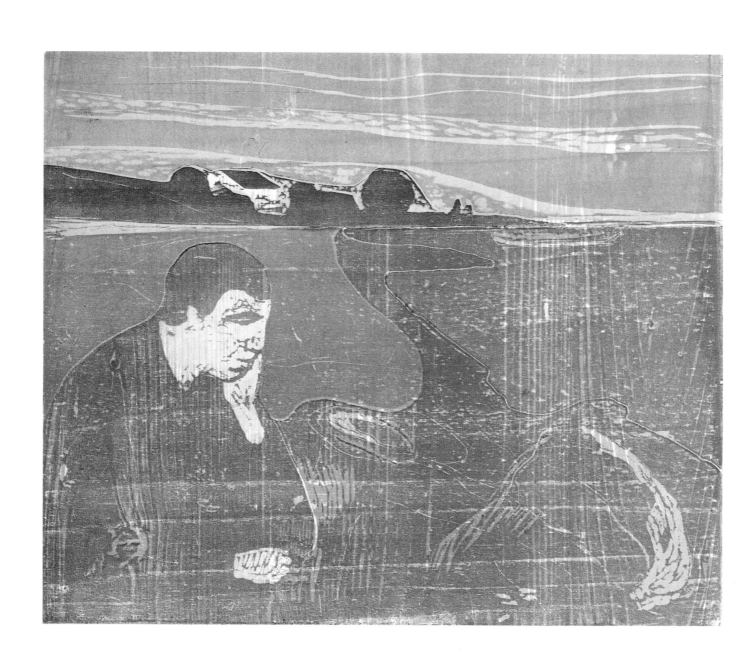

Down here on the beach I seem
to find an image of my-
self — of my life —
 Is it because
it was by the beach
we walked together that day?
 — The singular smell of seaweed
also reminds me of her
 — The strange rocks which mystically
rise above the water and take
the forms of marvellous creatures
which that evening resembled trolls —
 In the dark green
water I see the colors of her
eyes —

 Way way out there — the
 soft line where air meets
 ocean — it is incomprehensible — as
 existence — incomprehensible as
 death — eternal as longing

Melancholy, 1896
Color woodcut, 14⅞ × 18, PAS

THE URN .
REBIRTH –
OUT OF THE IMPURE SUBSTANCE
ROSE A FACE
FULL OF SORROW AND BEAUTY –

The Urn, 1896
Lithograph, $17^{15}/_{16} \times 10^{3}/_{8}$, HUAM

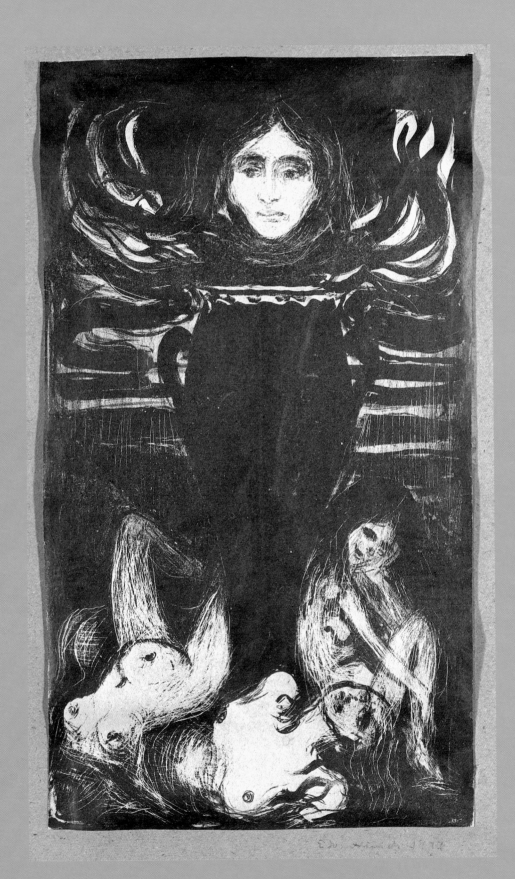

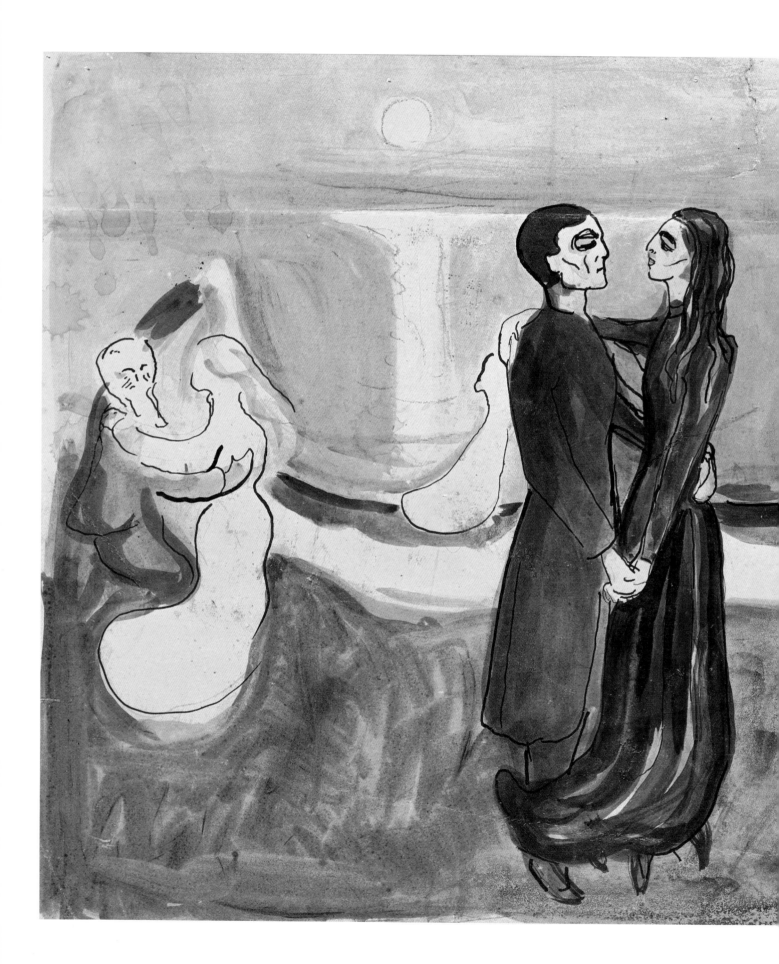

I started a new picture
The Dance of Life —
In the middle of a field
on a light summernight
a young minister
dances with a woman
with loosely hanging hair —
They look into
each other's eyes . . .
Behind them a wild crowd
of people are whirling —
fat men biting women
in the neck —
Caricatures of strong men
embracing the women —

125

The Dance of Life, 1899
India ink, 12¾ × 18¾, OKK

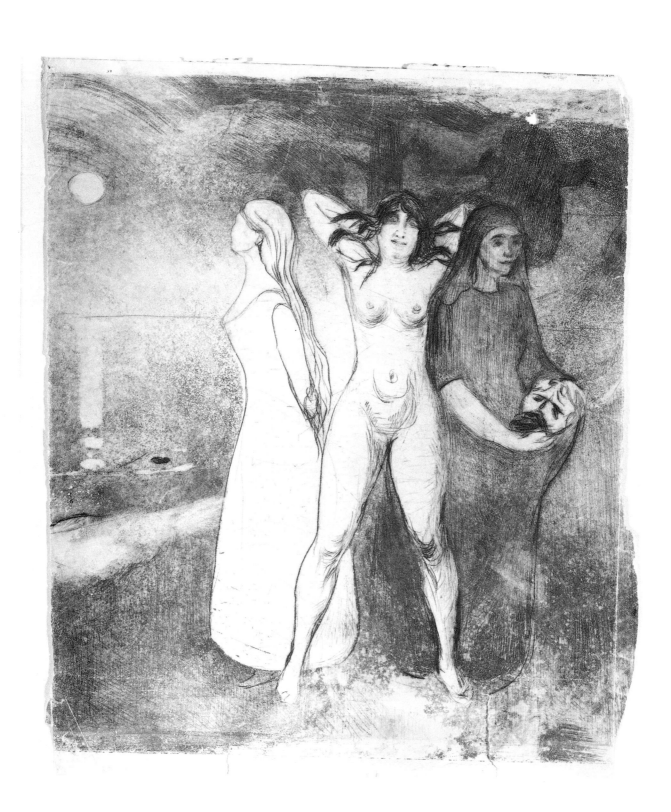

— You know my picture — A Woman —
the lighthaired woman of spring —
the whore — and the Sorrow
Her smile — which
from the alluring smile of spring
turns into a reflection
of a mother's happy smile —
The grimace of a mistress —
the mask's bloody smile of happiness —
the actress on Life's Theater —
— and the face of sorrow or night
has become the frightful image
of Medusa's head —

The Woman, 1895
Drypoint, aquatint, 12¼ × 10⅝, OKK

. . . . The three women —
— Irene — dressed in white
dreaming toward life —
— Maja the lusty — the naked
— The woman of sorrow —
with her staring pale face
between the trunks —
— Irene's fate — the nurse. . . .
— On a light summernight —
the darkly dressed woman of sorrow
was seen against the light naked body
in a kind of bathing costume —
The lusty white body
against the black colors of sorrow —
all in the mysterious light
of the light summernight . . .
The light summernight
where life and death,
day and night
walk hand in hand

The Woman, 1899
Lithograph, hand colored, 17¾ × 22½, NBJR

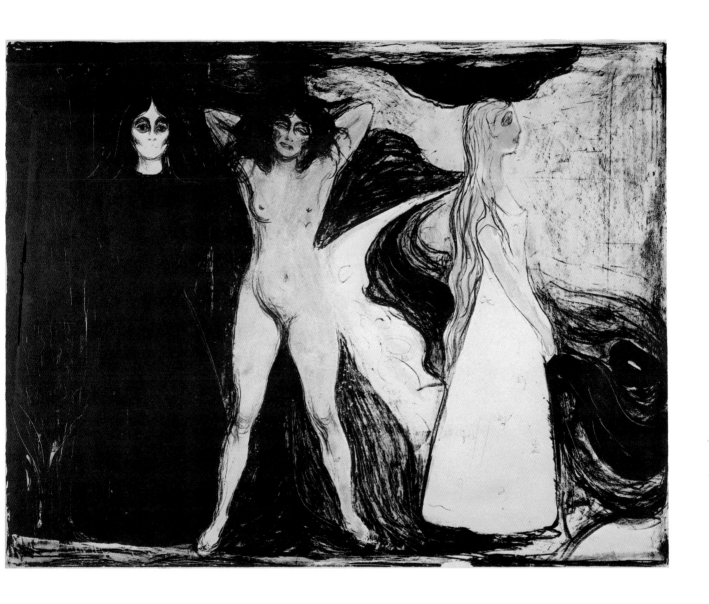

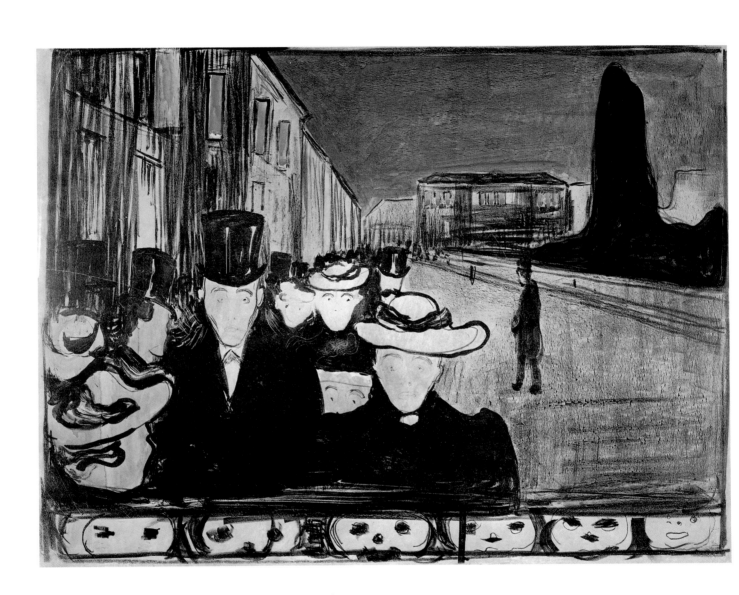

He strolled up and down Karl Johan It was 7 o'clock in
the evening — It was still light The sun had just disappeared
behind the horizon

There lay the Parliament building in a yellow-blue haze
with a deep blue sky above — High up was a pale little moon
pale and shy — But the windows in the Parliament building and
in the buildings along Karl Johan reflected yellow from the
horizon — they formed lines of shining squares
— He felt strangely weak the ladies were so beautiful
They actually looked fantastic — their faces shone pale
in the yellow light

How they all looked like her — And then she finally
came . . . Pale in the reflection from the horizon in a black dress
that fitted closely around her neck the full yellow-white neck
— He had never seen her as beautiful as now
She greeted him with a soft smile and walked on

Everything became so empty and he felt so alone
People who passed by looked so strange and awkward and he
felt as if they looked at him stared at him all these faces pale in
the evening light —

Evening on Karl Johan, 1896
Lithograph, hand colored, 19 × 21½, NBJR

I SAW ALL PEOPLE BEHIND THEIR
MASKS - SMILING PHLEGMATIC -
COMPOSED FACES -
I SAW THROUGH THEM AND
THERE WAS SUFFERING - IN THEM ALL -
PALE CORPSES — WHO
WITHOUT REST RAN AROUND —
ALONG A TWISTED ROAD - AT THE
END OF WHICH
WAS THE GRAVE -

Anxiety, 1896
Woodcut, hand colored, $17^{15}/_{16} \times 14^1/_8$, HUAM

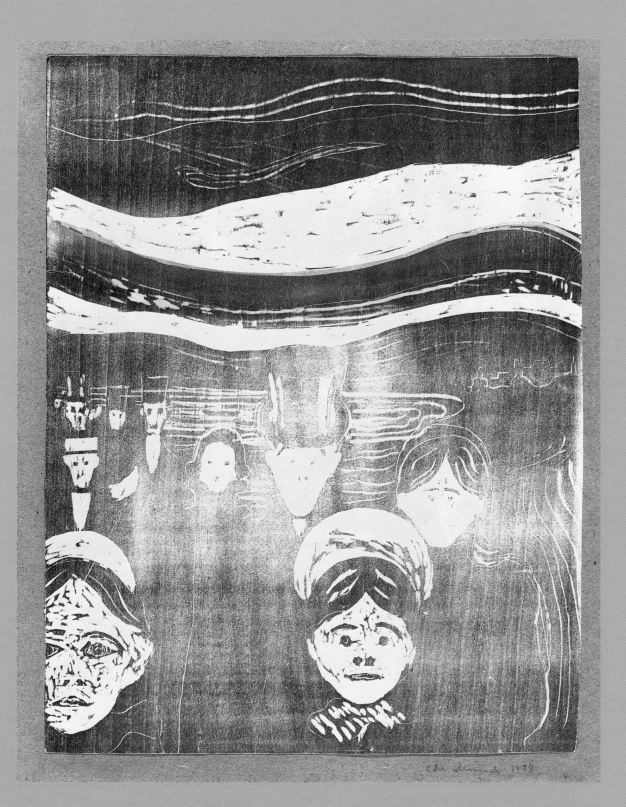

Jeg gik bortover
veien med to
venner _ så gik
sigtgik ned
Himmelen ble
pludselig blod ro
_ og jeg følte
et pust af vemod
_ vuring av angst
under hjertet _
Jeg standset, lened
mig til gjærdet
til døden _ over den
blaasorte fjor og by
lå blod i ildtunger
Mine venner gik
videre og jeg sto
igjen skjælvende
af angst _
og jeg følte det gik de
store unendelige
skrig gjennem
naturen

I walked along
the road with two
friends — then the
sun went down
Suddenly the sky
became bloody red
(— and I felt
a breath of sadness
— a sucking pain
beneath the heart)
I stopped, leaned
against the railing tired
to death — over the
blue-black fjord and city
lay blood and tongues of fire
My friends walked
on and I was left
trembling
with fear —
and I felt a
big unending
scream go through
nature

Despair, 1892
Charcoal, gouache, pencil, $14\frac{5}{8} \times 16\frac{5}{8}$, OKK

I walked along the road with two friends —
and the sun went down
The sky suddenly became blood — and I felt
as if a breath of sadness
I stopped — leaned against the railing
tired to death
Over the blue-black fjord and city lay clouds of dripping
steaming blood
My friends walked on and I was left in
fear with an open wound in my breast.
 a great scream went through nature

The Scream, 1895
Lithograph, hand colored, 13^{15}/$_{16}$ × 9^{15}/$_{16}$, OKK

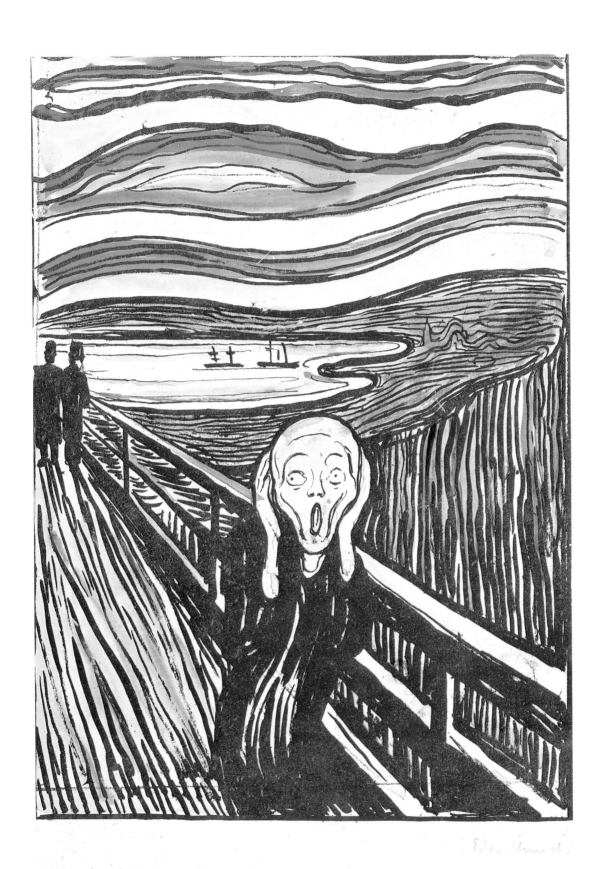

Geschrei

I WALKED ALONG THE ROAD
WITH TWO FRIENDS THEN
THE SUN WENT DOWN THE
SKY SUDDENLY BECAME
BLOOD AND I FELT
THE GREAT SCREAM IN
NATURE

The Scream, 1895
Lithograph, 13$\frac{7}{8}$ × 10, OKK

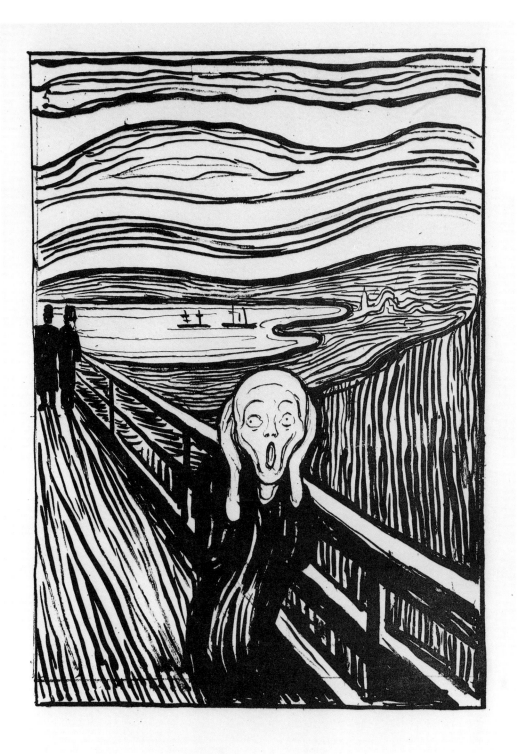

Geschrei

Ich fühlte das grosse Geschrei
durch die Natur

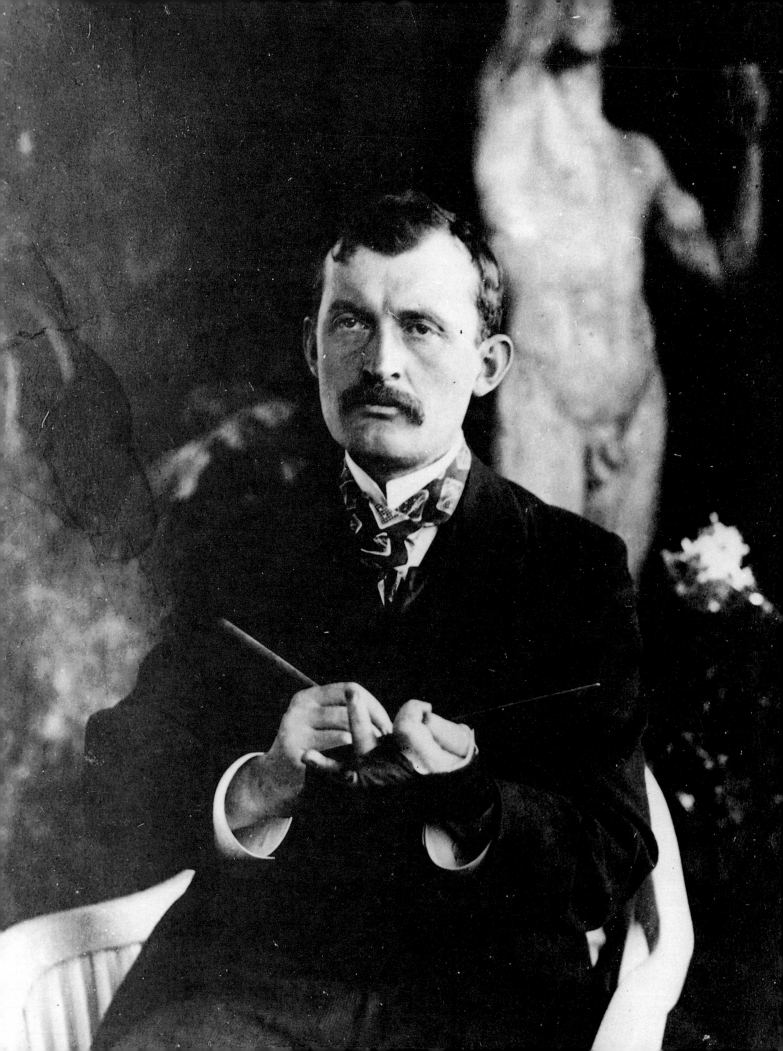

IN MY ART I HAVE TRIED TO EXPLAIN
TO MYSELF LIFE AND ITS MEANING -
I HAVE ALSO MEANT TO HELP OTHERS
TO CLARIFY THEIR LIVES

Edvard Munch working on a copper plate
in Dr. Max Linde's garden, Lübeck, 1902

I HAVE ALWAYS WORKED BEST
WITH MY PAINTINGS AROUND ME
I PLACED THEM TOGETHER
AND FELT THAT SOME OF THE PICTURES
RELATED TO EACH OTHER
THROUGH THE SUBJECT MATTER –
WHEN THEY WERE PLACED TOGETHER
A SOUND WENT THROUGH THEM
RIGHT AWAY AND THEY BECAME
QUITE DIFFERENT
THAN WHEN THEY WERE SEPARATE
THEY BECAME A SYMPHONY

142

Edvard Munch in his studio,
Ekely, Oslo, 1943

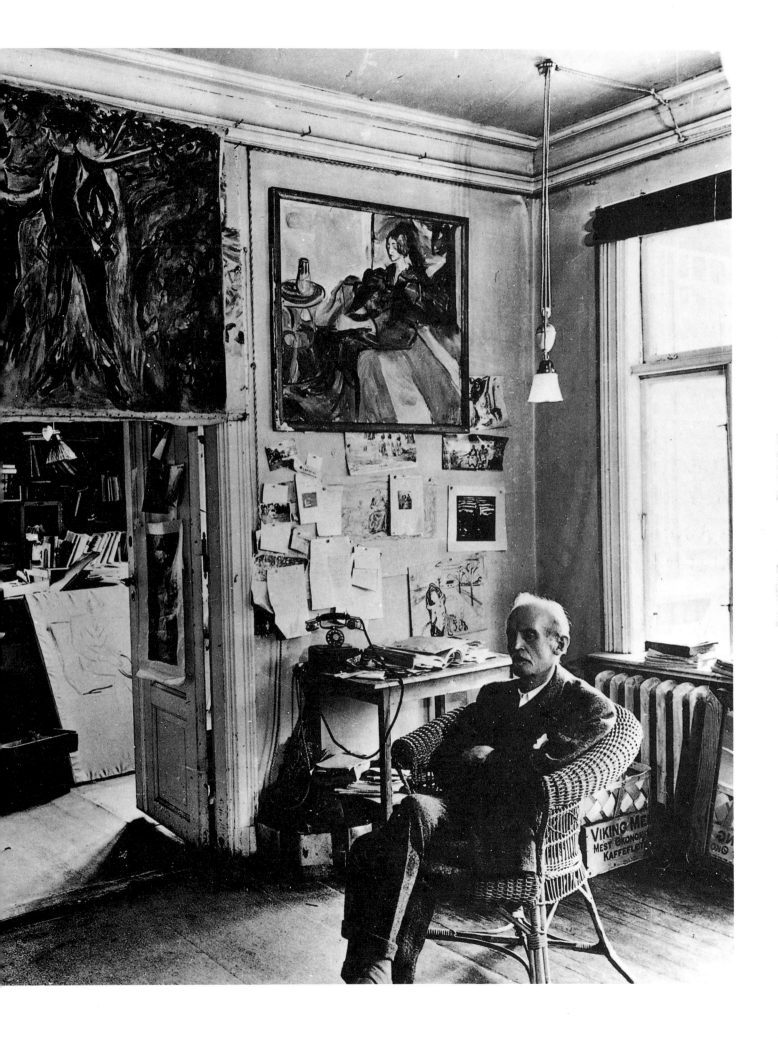

EM. 85

Edvard Munch
1888

Edv. Munch 9/5 89

E. Munch
1889.

E. Munch. Nice 1892

EM.

E Munch 04

E. Munch 84

E Munch 1906

E Munch 1914.15

E Munch 1914

Edv. Munch 1920

Edvard Munch
1923

E. Munch
1928

E. Munch
1930

BIOGRAPHICAL CHRONOLOGY

1863 December 12, Edvard Munch born in Løten, county of Hedemark, the second of five children by Christian Munch, medical corps physician, and Laura Cathrine, née Bjølstad.

1864 The family moves to Oslo (at that time called Christiania, later Kristiania).

1868 Munch's mother dies of tuberculosis; her sister Karen Bjølstad assumes responsibility of the household.

1877 Munch's fifteen-year-old sister, Sophie, dies of tuberculosis.

1879 Munch enters a technical college in Oslo to become an engineer.

1880 Poor health forces him to discontinue his studies; decides to become a painter.

1881 Enters the Oslo School of Design, attends classes in freehand and life drawing, taught by the sculptor Julius Middelthun.

1882 Rents a studio with six colleagues; the painter Christian Krohg critiques their work.

1883 Participates for the first time in an exhibition. Joins Fritz Thaulow's Open Air Academy in Modum, Norway.

1884 Offered a travel grant by Fritz Thaulow to go to Paris; the trip is postponed because of Munch's poor health. Establishes contact with the anarchist author Hans Jæger and other avant-garde writers and painters belonging to the Kristiania Bohême. Attends Thaulow's Open Air Academy in the fall.

1885 In May his first trip to Paris made possible by stipend from Fritz Thaulow. During the three-week stay, visits the Louvre; impressed by the work of Manet. In the fall begins working on the major paintings, *The Sick Child*, as well as *The Day After* and *Puberty*, completed in 1886 (both paintings were later destroyed).

1886 Four Munch paintings included in Oslo's annual Fall Exhibition. *The Sick Child* causes vociferous negative reactions. While in prison, Hans Jæger mentions a first version of Munch's *Madonna* in his periodical, *Impressionisten*.

1888 Munch's first visit to Åsgårdstrand, a small resort village on the Oslo fjord. He returned to Åsgårdstrand almost every summer, here finding important motifs for his paintings.

1889 Shows 110 works at the first one-man exhibition ever held in Norway. Rents a house in Åsgårdstrand. Receives a State Scholarship. In October travels to Paris; studies at the school of Leon Bonnat. His father dies unexpectedly in November; Munch is unable to return in time for the funeral. Moves to Saint-Cloud, a suburb of Paris.

1890 Shares living quarters in Saint-Cloud with the Danish poet Emanuel Goldstein. Studies with Bonnat in the mornings; spends time with Scandinavian artists and writers. Returns to Norway in May, summer in Åsgårdstrand. Receives another State Scholarship, travels in November by boat to Le Havre. Is hospitalized with rheumatic fever.

1891 January–April in Nice, then Paris. Summer in Norway. Third renewal of State Scholarship. Participates in the Fall Exhibition and returns to Nice via Paris. Goldstein commissions a vignette for his collection of poems, *Alruner.*

1892 In Nice until March, finishes the vignette for *Alruner.* Returns to Norway, makes illustrations and title vignette for a book by the poet Vilhelm Krag (the illustrations were never published). Summer in Åsgårdstrand. In October invited by the Verein Berliner Künstler to exhibit in Berlin. The exhibition causes controversy and closes after one week, despite protests from a minority of the Verein artists. Makes important paintings such as *The Kiss, Puberty, The Day After, Despair, Evening on Karl Johan, Death in the Sickroom* (pastel).

1893 Berlin. Frequents an international group of artists and writers, the so-called Schwarze Ferkel group, whose most prominent member was the Swedish dramatist August Strindberg. Exhibits in Dresden, Munich, and Berlin. In June both Munch and Strindberg are represented with paintings at a salon de réfusé in Berlin. Creates a number of important paintings such as *The Scream, The Voice, Starry Night, Madonna, Vampire, and Melancholy.* December, one-man exhibition in Berlin; six of the paintings were exhibited under the title Study for a Series: Love. Makes his first etchings and engravings.

1894 Berlin. *Das Werk von Edvard Munch* is published in July, with essays by Stanislaw Przybyszewski, Willy Pastor, Franz Servaes, and Julius Meier-Graefe. Summer in Norway. September, exhibition in Stockholm in which fifteen of the paintings are exhibited under the title Study for a Mood Series: Love. Meets the Ibsen translator Count Prozor and the French theater director Lugné-Poë. Makes his first lithographs.

1895 Berlin. Exhibits twenty-eight paintings, fourteen of them as a series under the title Love. Meier-Graefe publishes a portfolio of eight Munch etchings. Summer, returns to Åsgårdstrand, after a brief stay in Paris. October, exhibition in Oslo, reviewed in November by Thadée Natanson in *La Revue Blanche.* A lithograph of *The Scream* is published in *La Revue Blanche* in December. Begins to express major themes from his paintings in etchings and lithographs.

1896 End of February travels to Paris, where he remains until late spring of the next year. Has contact with, among others, Meier-Graefe, Frederick Delius, August Strindberg, Vilhelm Krag, Sigbjørn Obstfelder, William

Molard, and a number of intellectuals connected with the periodical *Mercure de France*. First woodcuts and color lithographs; makes prints at the famous printing house of Auguste Clot. May exhibition at the Salon de l'Art Nouveau; reviewed by Strindberg in *La Revue Blanche* in June. Meets Stéphane Mallarmé, makes a lithograph and an etching of him. Works on illustrations (never published) for Baudelaire's *Les Fleurs du mal*. Makes a lithograph for a program of Ibsen's *Peer Gynt* at Théâtre de l'Oeuvre. Paints a second version of *The Sick Child*.

1897 Winter and spring in Paris; in March exhibits at La Libre Esthétique in Brussels, April and May at the Salon des Indépendants in Paris. July, travels to Åsgårdstrand, where he buys a small house. September and October, has large retrospective exhibition in Dioramalokalet, Oslo; the graphic series The Mirror included. Announces his intention to publish a number of portfolios of The Mirror.

1898 In Norway until March. Via Copenhagen and Berlin travels to Paris and participates at the Salon des Indépendants. Returns to Norway in June, spends the rest of the year in Oslo and in Åsgårdstrand. Meets Tulla Larsen. Commissioned to provide illustrations for an edition of the German periodical *Quickborn*, devoted to Strindberg's writing.

1899 In April travels to Italy via Berlin, Paris, and Nice. Visits Florence, in May goes to Rome and studies Raphael. Returns in the summer, via Paris, to Åsgårdstrand. Makes important woodcuts. Begins working on his painting *The Dance of Life*. In the fall and winter convalesces at a sanatorium in Gudbrandsdalen.

1900 Leaves Norway in March, travels via Berlin to Florence and Rome. Spends some time at a sanatorium in Switzerland. In July, to Como, Italy. Returns to Norway.

1901 Remains in Norway; in late fall to Berlin. Paints portraits and landscapes.

1902 Winter and spring in Berlin. In March and April, exhibits at the Berliner Secession twenty-two paintings under the title Frieze: Presentation of a Sequence of Pictures from Life. The summer in Åsgårdstrand. During an argument with Tulla Larsen injures a finger on his left hand with a gunshot. Relationship with Tulla Larsen ends. In the fall, meets Dr. Max Linde of Lübeck, who becomes a patron. Dr. Linde commissions the "Linde Portfolio": fourteen etchings and two lithographs (portraits, house, garden). December, meets Judge Gustav Schiefler in Berlin, who initiates his important work of cataloging Munch's graphic oeuvre.

1903 Winter in Berlin. February, to Leipzig, where he exhibits paintings and prints. Nineteen of the paintings are from The Frieze of Life series. In March he goes to Paris. Visits the composer Frederick Delius in Grez-sur-Loing. Becomes a member of the Société des Artistes Indépendants. April to Dr. Linde in Lübeck; summer in Åsgårdstrand; fall in Berlin. Meets the violinist Eva Mudocci.

1904 Winter in Berlin. Concludes contract with Bruno Cassirer for exclusive right to sell his graphic work, and with Commeter in Hamburg for his

paintings. Becomes a member of the Berliner Secession. March through May in Weimar and Lübeck. Summer in Åsgårdstrand. To Lübeck in August, where Dr. Linde commissions him to make a frieze for his children's room. End of August exhibits in Copenhagen; quarrels and fights with the author Andreas Haukland. September in Åsgårdstrand. October, large exhibition in Oslo, where eighteen of the paintings are presented under the title Motifs from the Modern Soul's Life. At the end of November to Lübeck via Berlin; Dr. Linde informs him the frieze is unfit for his children's room. Instead, he buys other Munch paintings. Writes "The City of Free Love."

1905 January, Berlin. In February to Prague for the opening of a large, retrospective exhibition; fifteen of the paintings included shown under the title Life. To Hamburg and Berlin; spring in Åsgårdstrand. Violent fight and quarrel with the painter Ludvig Karsten. September to Chemnitz, November in Bad Elgersburg, Thüringen, where he tries to cure alcoholism and nervous disorder.

1906 Stays through the summer at Bad Kösen and Bad Ilmenan. To Weimar, paints portraits of Harry Graf Kessler and Elizabeth Förster-Nietzche, sister of the philosopher. Makes a portrait of Friedrich Nietzche from a photograph, at the request of the Swedish banker Ernst Thiel. During the summer, makes stage-set sketches for Ibsen's Ghosts, for Max Reinhardt's theater, Kammerspiele, Deutsches Theater, in Berlin. In November, begins stage-set sketches for Hedda Gabler. Begins working on a third version of the painting The Sick Child.

1907 Winter in Berlin, continues working on the Hedda Gabler project, and on a decoration for the foyer in the Kammerspiele theater (the so-called Reinhardt frieze). April to Stockholm, paints portrait of Ernst Thiel, who buys a number of his important paintings. Summer and fall in Warnemünde; commences the triptych, Bathing Men. Settles in Berlin in December.

1908 Berlin. In February short visit to Paris, then to Warnemünde, where he spends the spring and summer. Jens Thiis, director of the National Gallery in Oslo, purchases several important Munch paintings, despite public protests. In the fall to Hamburg, Stockholm, and Copenhagen, where he suffers a nervous breakdown. Enters Dr. Daniel Jacobson's clinic in October. Is made Knight of the Royal Norwegian Order of St. Olav.

1909 Remains at Dr. Jacobson's clinic through the spring. While there, he makes the lithographic portfolio Alpha and Omega, accompanied by a long prose poem. Paints Dr. Jacobson and a number of friends. Makes animal sketches in the Zoo. Becomes Honorary Member of the Art Association, Manes, in Prague. Returns to Norway in May; rents a property near Kragerø, on the coast of southern Norway. June to Kristiansand and Bergen, where Rasmus Meyer makes large purchases of his paintings. In August, short trips to Lübeck and Berlin. Initiates sketches for the Oslo University Assembly Hall (the Aula).

1910 Winter and spring at Kragerø, purchases a property at Hvitsten, on the 149

east side of the Oslo fjord, to ensure sufficient working space. Continues to work on the Aula decorations.

1911 Short visit to Germany, spends most of this year at Hvitsten. Wins the competition for the Aula decorations, continues to work on these pictures. Fall and winter in Kragerø.

1912 Winter in Kragerø. In May via Copenhagen to Paris (exhibition) and to Cologne, where he has a special room at the Sonderbund Ausstellung (as have Cezanne, Gauguin and Van Gogh).

1913 Needs more working space and rents the Grimsrød estate at Jeløya, near Moss. Travels extensively: in April to Berlin, Frankfurt, Cologne, Paris, London. In August to Stockholm (exhibition), Hamburg, Lübeck and Copenhagen. Spends the fall in Norway. Participates at the Armory Show in New York with eight graphic works. Receives many tributes on his fiftieth birthday, December 12.

1914 In January to Copenhagen, Frankfurt, Berlin, and Paris. February to Berlin, spends the rest of the year in Norway. On May 29 the University of Oslo accepts Munch's proposed works for the Aula decorations, despite years of controversy at the University.

1915 Spends most of the year in Norway, working on the Aula decorations. In November exhibits in Copenhagen. Gives financial aid to young German artists.

1916 Buys the property, Ekely, in the outskirts of Oslo, where he is to spend most of his time until his death. Aula decorations unveiled September 19. Makes a fourth version of the painting, *The Sick Child*.

1917 Resides at Ekely, except for short trips within Scandinavia. Curt Glaser's biography on Munch published in Germany.

1918 Publishes the pamphlet *Livsfrisen* in connection with an exhibition at Blomquist's in Oslo. Works on new versions of motifs from The Frieze of Life.

1919 Continues making new versions of The Frieze of Life motifs. Contracts severe influenza.

1920–1921 Travels to Berlin, Paris, Wiesbaden, Frankfurt; exhibitions in Germany and Scandinavia. Landscape paintings, lithographs.

1922 Spends most of his time at Ekely. Paints murals (oil on canvas) for the worker's dining room at the Freia Chocolate Factory in Oslo. April and May travels to Wiesbaden, Zurich, Berlin. Purchases seventy-three graphic works by German artists to help support them.

1923 Continues his support for German artists; becomes a member of the German Academy.

1924 Donates graphic works to raise funds for German artists. Paints portraits, landscapes. Travels in Norway.

1925 Elected honorary member of the Bavarian Academy of Fine Arts, Munich. Travels in the Norwegian mountains.

1926	Munch's sister Laura dies. Travels on the continent in spring and fall. Represented at the Carnegie International Exhibition in Pittsburgh. Starts painting the fifth version of *The Sick Child*.
1927	February to Berlin, where he has a large retrospective exhibition, shown in the summer at the National Gallery, Oslo. Goes to Munich, Rome, Florence in March. Returns in April via Berlin and Dresden. Summer in Norway.
1928	Works on large sketches for a wall decoration, The Worker Frieze, intended for Oslo City Hall, then under construction. Exhibits in Munich, San Francisco, Stockholm, London.
1929	Builds a large winter studio at Ekely; remains there all year. Attempts to organize his written work. Large exhibition of his graphics in Stockholm; numerous exhibitions on the continent.
1930	Suffers from an eye disease.
1931	His eye problems continue. Karen Bjølstad, his aunt, dies. Represented at exhibitions in Europe and the United States (Detroit and Carnegie International in Pittsburgh).
1932	Remains at Ekely. Exhibition in Zurich, Edvard Munch and Paul Gauguin.
1933	Works on a new version of *Alma Mater*, one of his Aula paintings. Receives numerous tributes on his seventieth birthday; is made Knight of the Grand Cross of the Order of St. Olav. Books on Munch by Jens Thiis and Pola Gauguin (the painter's son) are published.
1934	Presents his portrait of August Strindberg (1892) to the National Museum, Stockholm. Exhibits in Oslo, Riga, and Pittsburgh (Carnegie International).
1936	Continues his design for the Oslo City Hall, but abandons the project at the end of the year.
1937	Eighty-two works by Munch confiscated by the Nazi government in Germany and declared "entartete Kunst" (degenerate art). Gives economic support to the German artist Ernst Wilhelm Nay to enable him to visit Norway.
1938	Recurrence of his eye problems.
1940	His eye problems continue. Refuses to have any contact with the German Nazi invaders or their Norwegian collaborators. Paints the self-portrait *Between the Clock and the Bed*.
1941	Grows potatoes, vegetables and fruit on a large scale, at Ekely and Hvitsten, as a result of the wartime food shortage.
1943	Works energetically at Ekely. Receives numerous tributes on his eightieth birthday. Witnesses the large explosion in Oslo's Filipstad Harbor on December 19. Catches a cold which worsens.

1944 January 23, dies peacefully at his Ekely home. All the works in his possession bequeathed to the City of Oslo—about 1,000 paintings, 15,400 prints, 4,500 watercolors and drawings, numerous etching plates, lithographic stones and woodblocks, 6 sculptures, letters, manuscripts, as well as his library consisting of some 6000 items. After her death in 1952, Munch's sister Inger left the City of Oslo an additional 15 paintings and her brother's correspondence that was in her possession.

In 1949, the City of Oslo voted to build a museum to house Munch's work.

On May 29, 1963, the Munch-museet was inaugurated at Tøyen, Oslo.

The Biographical Chronology is partly based on Johan Langaard and Reidar Revold's A Year by Year Record of Edvard Munch's Life *(Oslo, 1961).*

NOTES TO MUNCH'S TEXTS

In the following notes I refer to articles in the exhibition catalogue *Edvard Munch: Symbols & Images*, National Gallery of Art, Washington, DC, November 1978–February 1979, as *Symbols & Images*.

A number of texts referred to in the notes are taken from OKK T 2782, the so-called Moss ledger. Into this ledger, which is almost surely from 1915, Munch inserted pages with notes written at earlier dates. Various headings indicate that he planned to organize his writings in this ledger according to subject matter, such as "Childhood," "Art," "Philosophy," "Moods," etc. See Gerd Woll, "The Tree of Knowledge of Good and Evil," *Symbols & Images*, p. 233.

Many of the texts are taken from Munch's album The Tree of Knowledge of Good and Evil. Texts from this album are mentioned in the notes only with the registration number, OKK T 2547, and subsequent page number. An "A" before the number designates loosely inserted pages. All the texts from OKK 2547 are reproduced in *Symbols & Images*, pp. 249–255.

Some of the texts are capitalized in the hand lettering. When a text in capital letters was not originally written that way, this is noted: "Not in capital letters."

Finally, several of the dates given here are tentative since uncertainties still remain on the exact dates of a number of Munch's texts.

13 From OKK T 2782-ba, written in Paris, September 1896. From the same text as the one referred to in note 16 to my introduction. Not in capital letters.

48 "What is art . . .," from OKK T 2776, Elgersburg 1905. Not in capital letters. "I do not believe . . .," from OKK N 29, ca. 1890–1891. Not in capital letters.

50 From OKK T 2759, most likely written in 1904. The text is part of a longer one in which Munch looks back at his relationship with Tulla Larsen, which ended in September 1902. In one place Munch writes: "It was now 1½ years since I left her . . ."

52 "These basically sick years . . .," from OKK N 37, probably written, like the following text, in 1932–1933 in response to questions from Jens Thiis, who was working on a biography of Munch, published in 1933. "I therefore do not mean . . .," from OKK N 46, 1932–1933.

55–58 OKK T 2771, autobiographical note, dated Saint-Cloud, February 5, 1890.

60–61 From OKK N 45, an unfinished draft, probably to Jens Thiis, 1932–1933. Not in capital letters.

63 From an undated note entitled *Ibsen og Livsfrisen* (Ibsen and The Frieze of Life), without OKK number. Probably from 1929; a fairly similar description is included in the pamphlet *Livsfrisens tilblivelse* (The Genesis of The Frieze of Life) from that time. See Arne Eggum, "The Theme of Death," *Symbols & Images*, p. 147.

65 In Edvard Munch, *Livsfrisens tilblivelse*, Oslo, undated (1929), p. 10. Not in capital letters.

66 From a note in "Violet Book," OKK T 2760, dated Nice, January 8, 1892. About "Violet Book," see Trygve Nergaard, "Despair," *Symbols & Images*, note 31, p. 140.

68 From OKK N 59, ca. 1892. Not in capital letters.

69 From OKK T 2782-r, ca. 1892.

70 From OKK T 2782-s, ca. 1892–1893. Not in capital letters.

72 Text written beneath the drawing OKK T 329, dated 1893–1896. Very similar texts to be found in OKK T 2782-al and OKK T 2782-ab.

73 From OKK T 2782-al, ca. 1892–1893.

75 From OKK T 2782-ah, ca. 1893–1894. Not in capital letters.

76 From OKK T 2781-h, autobiographical note ca. 1891–1892, in which Munch refers to himself as Brandt and to Mrs. Milly Ihlen as Mrs. Heiberg. The scene described took place at the Grand Hotel in Åsgårdstrand, from which the landscape depicted in *Starry Night* could be seen.

78 OKK T 2547-A45, ca. 1912–1915. Written with colored crayons in capital letters. See *Symbols & Images*, p. 254.

80 From OKK T 2782-al, ca. 1892–1893; taken from the same text as the one on p. 73. Not in capital letters.

83 From OKK T 2781-y, autobiographical note, ca. 1891–1892.

85 From OKK T 2783, pp. 46–47. This notebook contains several texts fairly similar to some in "The Tree of Knowledge." The date is uncertain, although it may have been written after the break with Tulla Larsen. Ca. 1905–1908.

86 OKK T 2547-A1, written with colored crayons in capital letters, see *Symbols & Images*, p. 249.

88 From OKK T 2782-au, ca. 1893–1894.

91 OKK T 126–68, ca. 1894. Not in capital letters. In "The Tree of Knowledge" Munch wrote two texts for *Madonna*, both identical in content, but different in execution: OKK T 2547-24 is written in red watercolor in capital letters, OKK T 2547-A35 with colored crayons in capital letters. See *Symbols & Images*, p. 252.

93 From OKK N 30, ca. 1895. Not in capital letters. In this note Munch briefly described several paintings belonging to his series Love. See Reinhold Heller, "Love as a Series of Paintings," *Symbols & Images*, p. 103.

95 OKK T 2547-64, ca. 1912–1915. Text writ-

ten in pencil and watercolor. See *Symbols & Images*, p. 254.

96 OKK T 2601, in a sketchbook from Paris, 1896, p.13.

99 OKK T 2547-A47, ca. 1912–1915. Written on heavy paper with colored crayons in capital letters. See *Symbols & Images*, p. 254.

101 From OKK T 2782-c, ca. 1896. The text is taken from one quite similar to the text rendered on p. 96. Not in capital letters.

102 OKK T 2771, ca. 1892–1893. For a very similar, probably later text, see OKK T 2782-p, entitled *My Madonna*.

105 From OKK 2781-ah, autobiographical note, ca. 1892–1893.

106 OKK T 2547-A51, ca. 1912–1915. Translated by Alf Bøe. Written with red crayon in capital letters. See *Symbols & Images* p. 254.

108 From OKK T 2782-s, ca. 1892–1893.

111 OKK T 2547-A37, ca. 1912–1915. Translated by Alf Bøe. Written with colored crayons in capital letters, see *Symbols & Images*, p. 254.

112 OKK T 2782-l. Date uncertain. Reinhold Heller believes it is written between 1892 and 1894 (see Heller, *Munch: His Life and His Work*, London, 1894, note 87, p. 231). Gerd Woll relates the text to the woodcut *Man's Head in Woman's Hair*, 1896 (see Woll, op. cit. p. 242). I suggest 1898 as a tentative date. The initial sentence in this text: "Darkness descended deep-violet over the entire earth," distinguishes itself as a description quite different from any of Munch's other texts from the 1890s. In Max Dauthendey's *Die Schwarze Sonne* (1897) there are similar descriptions.

115 From OKK T 2782-s, ca. 1892–1893. Not in capital letters. From the same text as the one rendered on p. 108 and p. 70.

116 OKK T 2547-a43, ca. 1912–1915. Written on brownish paper with colored crayons in capital letters. See *Symbols & Images*, p. 254. A similar but more detailed text from 1896 occurs in OKK T 2601, p.14.

119 From OKK T 2782-bw, late summer of 1892. Date according to Trygve Nergaard. See his essay "Despair," op. cit., note 42, p. 141. A quite similar text occurs in OKK T 2782-r.

120 From OKK T 2782-j, late summer of 1892, according to Nergaard, op. cit., p. 131.

122 OKK T 2547-A39, ca. 1912–1915. Translated by Alf Bøe. Written with colored crayons, the two first words in lowercase letters, the remaining in capital letters. See *Symbols & Images*, p. 253.

125 From OKK T 2800, written during or after April 1908. The note, initiated with a listing of prints he sent to Blomquist in Oslo, April 6, 1908, is taken from a longer description of Munch's relationship with Tulla Larsen.

127 From OKK T 2759, ca. 1904. Taken from the same text as the one on p. 50.

128 From a folder entitled "Ibsen og livsfrisen" (Ibsen and The Frieze of Life), without OKK number, probably written in 1929. A fairly similar text is printed in *Livsfrisens tilblivelse*, pp. 13–17. In this text, Munch tells about his exhibition at Blomquist's in 1895, and how Henrik Ibsen showed particular interest in *Woman* when he came to see the exhibition. In the text here, Munch wrote the names of the women in Ibsen's *When We Dead Awaken* for each of the women in his picture.

131 From OKK T 2761, autobiographical note, ca. 1890.

133 From OKK T 2782-x, date uncertain, ca. 1897–1898? Not in capital letters. In "The Tree of Knowledge," there is a similar but more simplified text, written with red crayon in capital letters, OKK T 2547-A41. See *Symbols & Images*, p. 254.

135 Text written in pencil, next to the images of "Despair," OKK T 2367, 1892. In the fourth line from the end, Munch added in pencil, barely visible, the words "gik et" following the "det"; in the third but last line, he added a faint "t" over the "e" in "store," thus changing the text from "I felt the big unending scream through nature" to "I felt a big unending scream go through nature."

136 OKK T 2782-as, ca. 1897–1898? The date is uncertain; Heller suggests 1905 as a possible date. See Heller, *The Scream*, London, 1973, p. 106. Heller, in op. cit. lists a number of the different texts Munch wrote to this motif, pp. 103–109.

138 OKK T 2547-53, ca. 1912–1915. Written in capital letters in multicolored watercolor. See *Symbols & Images*, p. 253.

141 From OKK N 46, ca. 1932. Not in capital letters. A very similar text in OKK N 62.

142 Ibid.

LIST OF ILLUSTRATIONS

Note: Extant prints from The Mirror series of 1897 are here reproduced with a small band of the original cardboard showing, including Munch's signature and date. Measurements are given in inches followed by centimeters.

SELECTED BIBLIOGRAPHY

Berman, Patricia G. *Edvard Munch: Mirror Reflections.* Catalogue, The Norton Gallery of Art, Florida, March–April 1986.

Decknatel, Frederick. *Edvard Munch.* Catalogue, Institute of Contemporary Art, Boston, April–May 1950.

Eggum, Arne. *Edvard Munch: Paintings, Sketches and Studies.* Oslo: J.M. Stenersens Forlag, 1984.

———— "The Green Room," in *Edvard Munch,* catalogue, Liljevalchs Konsthall and Kulturhuset, Stockholm, March–May 1977, pp. 82–100.

Epstein, Sarah G. *The Prints of Edvard Munch: Mirror of His Life.* Edited by Jane van Nimmen. Catalogue, Allen Memorial Art Museum, Oberlin College, Oberlin, OH, March 1983.

Guenther, Peter W. *Edvard Munch.* Catalogue, The Sarah Campbell Blaffer Gallery, University of Houston, Houston, April–May 1976.

Heller, Reinhold. *Munch: The Scream,* London: The Penguin Press, 1973.

———— "Love as a Series of Paintings," *Edvard Munch: Symbols & Images.* Catalogue, National Gallery of Art, Washington, DC, November 1978–February 1979, pp. 87–111.

———— *Munch: His Life and Work.* London: John Murray Publishers, 1984.

Hodin, J. P. *Edvard Munch.* London: Thames and Hudson, 1972.

Hougen, Pål. *Edvard Munch and Henrik Ibsen.* Catalogue, St. Olaf College, Northfield, MN, March–April 1978.

Lathe, Carla. *Edvard Munch and His Literary Associates.* Catalogue, University of East Anglia, Norwich, England, June–October 1979.

Messer, Thomas. *Edvard Munch.* New York: Harry N. Abrams, 1973.

Morrisey, Leslie D. "Edvard Munch's 'Alfa og Omega'," *Arts Magazine* LIV (January 1980): 124–129.

Prelinger, Elizabeth. *Edvard Munch, Masterprinter.* New York/London: W. W. Norton, 1983.

Smith, John Boulton. *Frederick Delius and Edvard Munch: Their Friendship and Their Correspondence.* London: Triad Press, 1983.

Stang, Ragna. *Edvard Munch: The Man and the Artist.* New York: Abbeville Press, 1979.

Steinberg, Stanley, and Joseph Weiss. "The Art of Edvard Munch and Its Function in His Mental Life." *Psychoanalytical Quarterly* 23 (1954): 409–423.

Stenersen, Rolf. *Close-up of a Genius.* Oslo: Gyldendal, 1969.

Timm, Werner. *The Graphic Art of Edvard Munch.* Greenwich, CT: New York Graphic Society, 1969.

Torjusen, Bente. "The Mirror," in *Edvard Munch: Symbols & Images.* Catalogue, National Gallery of Art, Washington, DC, November 1978–February 1979, pp. 185–227.

Woll, Gerd. "The Tree of Knowledge of Good and Evil," in *Edvard Munch: Symbols & Images.* Catalogue, National Gallery of Art, Washington, DC, November 1978–February 1979.

WORDS AND IMAGES OF EDVARD MUNCH

Design and hand-lettering by Clifford B. West
Design consulting and typography by Frank Lieberman
Typeset by the Dartmouth Printing Company in Optima and Trump
Printed and bound by Dai Nippon on New Age Matte, an acid-free paper